00619717

RENT

WIZSC

Interaction of Color

Original edition copyright © 1963 by Yale University. Paperback edition copyright © 1971 by Yale University. Revised paperback edition copyright © 1975 by Yale University. Revised and expanded paperback edition copyright © 2006 by Yale University.

All rights reserved.

This book may not be reproduced,

in whole or in part, in any form (beyond that copying permitted by Sections 107 and 108 of the U.S. Copyright Law and except by reviewers for the public press), without written permission from the publishers.

Yale University Press books may be purchased in quantity for educational, business, or promotional use. For information, please e-mail sales.press@yale.edu (U.S. office) or sales@yaleup.co.uk (U.K. office).

Set in Baskerville type

Original edition designed and set by Norman Ives Revised and expanded paperback edition designed and set by BW&A Books, Inc. Printed in Singapore by CS Graphics.

Library of Congress Control Number: 2005937432

18BN-13: 978-0-300-11595-6 (paper) 10 9 8 7 6 5 4 This book is my thanks to my students

TABLE OF CONTENTS

Foreword, by Nicholas Fox Weber ix Introduction 1

- I Color recollection—visual memory 3
- 11 Color reading and contexture
- 111 Why color paper—instead of pigment and paint 6
- IV A color has many faces—the relativity of color 8
- V Lighter and / or darker—light intensity, lightness 12
 Gradation studies—new presentations
 Color intensity—brightness
- VI 1 color appears as 2—looking like the reversed grounds 18

4

- VII 2 different colors look alike—subtraction of color 20
- VIII Why color deception?—after-image, simultaneous contrast
 - 1X Color mixture in paper—illusion of transparence 24
 - x Factual mixtures—additive and subtractive 27
 - XI Transparence and space-illusion 29 Color boundaries and plastic action
- x11 Optical mixture—after-image revised 33
- XIII The Bezold Effect 33
- XIV Color intervals and transformation 34
- xv The middle mixture again—intersecting colors 37
- xvi Color juxtaposition-harmony-quantity 39
- xv11 Film color and volume color-2 natural effects 45
- XVIII Free studies—a challenge to imagination 47
 Stripes—restricted juxtaposition
 Fall leaf studies—an American discovery
 - XIX The Masters—color instrumentation 52
 - xx The Weber-Fechner Law-the measure in mixture 54
 - xx1 From color temperature to humidity in color 59

22

- xx11 Vibrating boundaries—enforced contours 61
- xxIII Equal light intensity—vanishing boundaries 62
- xxIV Color theories—color systems 65
- xxv On teaching color—some color terms 68 Explanation of color terms Variants versus variety
- xxv1 In lieu of a bibliography—my first collaborators 74

Plates and commentary 75

FOREWORD

For over forty years, *Interaction of Color* has been a best-selling book, demonstrably altering the lives of its readers all over the world. It brings infinite personal pleasure while perpetually expanding the way that colors are used and perceived in art, architecture, textiles, interior design, and graphic media at every level of technology. But when it was initially published, *Interaction* was, like everything Josef Albers did, a brave experiment, and like all forays into the unprecedented, it was the subject of controversy.

For the most part, *Interaction* was highly praised, but occasionally the response was far from laudatory. Writers vary in their responses to negative criticism—some saying it is fine, since all that counts is the amount of coverage, others feeling stung. Josef Albers, who saw himself as something of a martyr to modernism, both regretted the attacks and was intrigued by them. Part of the fascination of being blasted was that it confirmed that he had really startled people and taken them beyond their normal comfort zone. Ever since he had left a world where art was practiced in an acceptable, academic way—in the academies of Berlin and Munich, and in the public education system in which he taught in his native Westphalia—and gone to the Bauhaus, he had known what it was to inspire such controversial response.

Bauhaus modernism may now be in the pantheon of acceptability, but back then it startled and displeased the larger audience. The same was true of Black Mountain College, where Albers went after 1933, when the Bauhaus closed, and where he remained for sixteen years; today that pioneering institution is worshiped, but at the time a lot of what was created there was viewed as a form of heresy. Later, in 1950, when Albers began his *Homages to the Square*, he was mocked. Twenty years after that, when he was the first living artist given a solo retrospective at The Metropolitan Museum of Art, the work that people like Clement Greenberg had lambasted was finally recognized for its ingenuity, integrity, and subsuming beauty. Now that half a century has passed it has achieved the status, however dubious, of being a blue chip financial commodity, but at the start it was, like any statement by a messiah, criticized vociferously.

When Yale University Press courageously, and with all of the superb standards required by as exacting an artist as Albers, brought out *Interaction of Color* in 1963, the publication generally had an easier time than most of the artist's ventures. This was equally true when the paperback version came out in 1971. But there was the occasional diatribe. And Albers, proud as he was of the sales and all the enthusiasm for the book, of the applause worldwide, was fascinated at being a lightning rod for dissent. The octogenarian clipped the few bad reviews that appeared along with dozens of favorable ones, and tried to find out more about their authors. The voices of "nay" appeared in obscure publications, but they still counted. One of the reasons the artist was so interested is that the things for which the critics attacked the books were exactly the elements that excited him the most, because they recommended such a radical departure from traditional, hidebound ways of seeing.

Arthur Carp was the author of an attack in the magazine *Leonardo*. To present the flaws, Carp wrote that Albers considered "good teaching . . . 'more a matter of right questions than . . . of right answers.' He deprecates 'self-expression,' as opposed to 'a basic step-by-step learning.' . . . Students are urged to use disliked colors in the hope they may overcome their prejudices." Carp used these points to demonstrate that "one doubts if Albers is really being helpful" and to justify the statement "Would that he were less of a dilettante (pejorative connotation)!"

Everything that Carp attacked, of course, was what Albers believed in and what others applauded. As Howard Sayre Weaver wrote in a review that appeared in 1963 following publication of the first edition, *Interaction of Color* was a "grand passport to perception." It assumed that glorious role because it was, "essentially, a process: a unique means of learning and teaching and experiencing."

Weaver referred to Albers's fondness for the words of John Ruskin: "Hundreds of people can talk, for one who can think. But thousands of people can think, for one who can see." Most people, sooner or later, have recognized the miraculous way in which Interaction of Color facilitates such seeing. In the 1963 Architectural Forum, a design teacher at Cooper Union was among those prescient enough to write, "Interaction of Color is the most comprehensive and intelligent, as well as the handsomest, book we yet have on this subject. It is an indispensable volume for the artist, architect, or teacher who finds a greater challenge in discovery than in a 'safe' color system." That same year, Dore Ashton, reviewing the book in Studio, was perceptive enough to recognize that Albers was the opposite of the pedagogue Carp accused him of being; rather, his achievement justified his comment that "teaching is not a matter of method but of heart." The year after the paperback came out, the poet Mark Strand, in Saturday Review, saw Josef Albers's work as demonstrating that "when color challenges the safe, enclosing geometrical properties of the pictorial surface, as it is meant to, it does so with a slowness and delicacy that are disarming and a beauty that is exhilarating."

What one person disdained, another saw as groundbreaking. Albers's approach was revolutionary, putting experimentation at the fore. It disputed traditional notions of taste. It sought to engage rather than merely inform.

As a keen observer of the human comedy, Albers was particularly aware that sometimes his detractors were well-known figures, and his champions obscure ones. Donald Judd, in ARTS Magazine in 1963, called Interaction of Color "primarily pedagogical." Judd went on with a mixture of moderate, pseudo-Hemingwayesque adulation-"The book makes, to put it simply, one unqualified point, that color is important in art. It does this very well."-and bizarre, incomprehensible disparagement: "The Interaction of Color is the best that can be done. It is just that it has all the Biblical possibilities, since it is clear and has limits, of anatomy or of the other subjects whose presence and perfection are supposed to define art. The book should be used but not that way." Albers would never know that Judd would, two decades later, following the older artist's death, rescind these words and make pilgrimages to Albers's studio, feeling that he had not done justice to what Interaction was all about and regretting his youthful arrogance. In any event, taking it all in stride, Albers was certainly pleased that an unknown academic at the University of Nevada in Las Vegas had been among those to get the main point, in spades, of Interaction: "In an age in which increased human sensibility has become such an obvious need in all areas of human involvement, color sensitivity and awareness can constitute a major weapon against forces of insensitivity and brutalization."

This was the point. The quality of heart, the impact on all of human life, was what Josef Albers sought in his approach. This above all is the reason that we are so pleased that Yale University Press, Josef Albers's partner through thick and thin for four decades, has remained in that role as splendidly as ever. Supportive of the artist's legacy as it was of him during his lifetime when he was in the act of creating, Yale has shown a wonderful and consistent understanding of the brazen, self-generating newness of the artist's approach. Thanks to that fine relationship, Albers's marvelous, unsettling revelations—unsettling to some, exhilarating to others—are again flourishing in this current incarnation of *Interaction of Color*. With its additional plates and refinement of other details, this new volume, which effectively updates what is now a "classic," allows Albers's courageous invitation to experimentation, openness, and intellectual and personal expansion to thrive. It invites readers to thrive as well—exactly as Josef Albers would have liked.

Nicholas Fox Weber

Interaction of Color

Introduction

The book "Interaction of Color" is a record of an experimental way of studying color and of teaching color.

In visual perception a color is almost never seen as it really is —as it physically is. This fact makes color the most relative medium in art.

In order to use color effectively it is necessary to recognize that color deceives continually. To this end, the beginning is not a study of color systems.

First, it should be learned that one and the same color evokes innumerable readings. Instead of mechanically applying or merely implying laws and rules of color harmony, distinct color effects are produced —through recognition of the interaction of color by making, for instance, 2 very different colors look alike, or nearly alike.

The aim of such study is to develop—through experience —by trial and error—an eye for color. This means, specifically, seeing color action as well as feeling color relatedness.

As a general training it means development of observation and articulation.

This book, therefore, does not follow an academic conception of "theory and practice." It reverses this order and places practice before theory, which, after all, is the conclusion of practice.

Also, the book does not begin with optics and physiology of visual perception, nor with any presentation of the physics of light and wave length.

1

Just as the knowledge of acoustics does not make one musical —neither on the productive nor on the appreciative side so no color system by itself can develop one's sensitivity for color. This is parallel to the recognition that no theory of composition by itself leads to the production of music, or of art.

Practical exercises demonstrate through color deception (illusion) the relativity and instability of color.

And experience teaches that in visual perception there is a discrepancy between physical fact and psychic effect.

What counts here—first and last—is not so-called knowledge of so-called facts, but vision—seeing. Seeing here implies <u>Schauen</u> (as in <u>Weltanschauung</u>) and is coupled with fantasy, with imagination.

This way of searching will lead from a visual realization of the interaction between color and color to an awareness of the interdependence of color with form and placement; with quantity (which measures amount, respectively extension and / or number, including recurrence); with quality (intensity of light and / or hue); and with pronouncement (by separating or connecting boundaries).

The table of contents shows the order in which exercises usually lead our investigation.

Each exercise is explained and illustrated not to give a specific answer, but to suggest a way of study.

Color recollection—visual memory

If one says "Red" (the name of a color) and there are 50 people listening, it can be expected that there will be 50 reds in their minds. And one can be sure that all these reds will be very different.

Even when a certain color is specified which all listeners have seen innumerable times—such as the red of the Coca-Cola signs which is the same red all over the country—they will still think of many different reds.

Even if all the listeners have hundreds of reds in front of them from which to choose the Coca-Cola red, they will again select quite different colors. And no one can be sure that he has found the precise red shade.

And even

if that round red Coca-Cola sign with the white name in the middle is actually shown so that everyone focuses on the same red, each will receive the same projection on his retina, but no one can be sure whether each has the same perception.

When we consider further the associations and reactions which are experienced in connection with the color and the name, probably everyone will diverge again in many different directions.

What does this show?

First, it is hard, if not impossible, to remember distinct colors. This underscores the important fact that the visual memory is very poor in comparison with our auditory memory. Often the latter is able to repeat a melody heard only once or twice.

Second, the nomenclature of color is most inadequate. Though there are innumcrable colors—shades and tones in daily vocabulary, there are only about 30 color names.

Color reading and contexture

The concept that "the simpler the form of a letter the simpler its reading" was an obsession of beginning constructivism. It became something like a dogma, and is still followed by "modernistic" typographers.

This notion has proved to be wrong, because in reading we do not read letters but words, words as a whole, as a "word picture." This was discovered in psychology, particularly in Gestalt psychology. Ophthalmology has disclosed that the more the letters are differentiated from each other, the easier is the reading.

Without going into comparisons and details, it should be realized that words consisting of only capital letters present the most difficult reading because of their equal height, equal volume, and, with most, their equal width. When comparing serif letters with sans-serif, the latter provide an uneasy reading. The fashionable preference for sans-serif in text shows neither historical nor practical competence.

First, sans-serifs were designed as letters not for texts but for captions, when pictorial reproductions were introduced with stone lithography. Second, they produce poor "word pictures."

INTERACTION OF COLOR

Interaction of Color

INTERACTION OF COLOR

Interaction of Color

This illustrates that clear reading depends upon the recognition of context.

In musical compositions,

so long as we hear merely single tones, we do not hear music. Hearing music depends on the recognition of the in-between of the tones, of their placing and of their spacing.

In writing, a knowledge of spelling has nothing to do with an understanding of poetry.

Equally, a factual identification of colors within a given painting has nothing to do with a sensitive seeing nor with an understanding of the color action within the painting.

Our study of color differs fundamentally from a study which anatomically dissects colorants (pigments) and physical qualities (wave length).

Our concern is the interaction of color; that is, seeing what happens between colors.

We are able to hear a single tone. But we almost never (that is, without special devices) scc a single color unconnected and unrelated to other colors. Colors present themselves in continuous flux, constantly related to changing neighbors and changing conditions.

As a consequence, this proves for the reading of color what Kandinsky often demanded for the reading of art: what counts is not the what but the how.

Why color paper instead of pigment and paint

When, more than 20 years ago, this systematic study of color was begun, it occurred almost as a matter of course that the studies would be done in color papers. At that same time there was some concern among teachers that students might be reluctant to substitute paper for paint. Since then, obviously, the attitude of students—and of teachers has changed.

In our studies, color paper is preferred to paint for several practical reasons. Paper provides innumerable colors in a large range of shades and tints ready for immediate use. Though a large collection is needed, it is not expensive to assemble when one does not rely on large prepared paper sets representing specific color systems, such as the Munsell or Ostwald Systems (the least desirable are "tuned" sets, claiming to be failure-proof).

Sources easily accessible for many kinds of color paper are waste strips found at printers and bookbinders; collections of samples of packing papers, of wrapping and bag papers, of cover and decoration papers. Also, instead of full sheets of paper, just cutouts from magazines, from advertisements and illustrations, from posters, wallpapers, paint samples, and from catalogues with color reproductions of various materials will do. Often a collective search for papers and a subsequent exchange of them among class members will provide a rich but inexpensive color paper "palette."

What are the advantages of working with color paper? First, color paper avoids unnecessary mixing of paints, which is often difficult, time-consuming, and tiring. This is true not merely for beginners alone.

Second, by not exposing the student to discouraging failures of mixing and imperfect matching of spoiled paints and papers, we not only save time and material, but, more important, gain a continued active interest. Third, color paper permits a repeated use of precisely the same color without the slightest change in tone, light, or surface quality. It permits repetition without disturbing changes caused by varying application of paint (thinner or thicker—even or uneven); without traces of hand or tool resulting in varying density and intensity.

Fourth, working with color paper rarely demands more equipment than paste (heavy rubber cement is best), and a single-edged razor blade instead of scissors. This eliminates tools and equipment for handling paints, and therefore is easier, cheaper, and more orderly.

Fifth, color paper also protects us from undesired and unnecessary addition of so-called texture (such as brush marks and strokes, incalculable changes from wet to dry, or heavy and loose covering, hard and soft boundaries, etc.) which too often only hides poor color conception or application, or, worse, an insensitive color handling.

There is another valuable advantage in working with color papers instead of with paints: in solving our problems again and again we must find just the right color which demonstrates a desired effect. We can choose from a large collection of tones, displayed in front of us, and can thus constantly compare neighboring and contrasting colors. This offers a training which no palette can provide.

IV A color has many faces the relativity of color

Imagine in front of us 3 pots containing water, from left to right:

WARM	LUKEWARM	COLD

When the hands are dipped first into the outer containers, one feels—experiences—perceives—2 different temperatures:

WARM (at left)

(at right) COLD

Then dipping both hands into the middle container, one perceives again 2 different temperatures, this time, however, in reversed order

(at left) COLD—WARM (at right)

though the water is neither of these temperatures, but of another, namely

LUKEWARM

Herewith one experiences

a discrepancy between physical fact and psychic effect called, in this case, a haptic illusion—haptic as related to the sense of touch—the haptic sense.

In much the same way as haptic sensations deceive us, so optical illusions deceive. They lead us to "see" and to "read" other colors than those with which we are confronted physically.

To begin the study of how color deceives and how to make use of this, the first exercise is to make one and the same color look different.

On the blackboard and in our notebooks we write: Color is the most relative medium in art. Challenging examples of very surprising color changes are shown. Then the class is invited to produce similar effects but is not given reasons or favorable conditions. It starts, therefore, on a trial-and-error basis.

Thus, continuing comparison—observation—"thinking in situations" is promoted, making the class aware that discovery and invention are the criteria of creativeness.

As a practical study we ask that 2 small rectangles of the same color and the same size be placed on large grounds of very different color.

Soon, these first trials are collected and separated into groups of more and less promise.

The class will become aware that change is a result of influence. The influencing color is distinguished from the influenced color.

It is discovered that certain colors are hard to change, and that there are others more susceptible to change.

We try to find those colors which are more inclined to exert influence and to distinguish them from those which will accept influence.

A second class exhibition of more advanced results should clarify that there are 2 kinds of changing influences working in 2 directions, light on the one side and hue on the other. And both occur simultaneously though in varying strength.

Since 2 pieces of the same paper, therefore of the same color, are to appear different—and, if possible, incredibly different we must compare them under equal conditions. The only colors which are factually different are the large grounds, though they are alike in size and shape.

Because of the laboratory character of these studies there is no opportunity to decorate, to illustrate, to represent anything, or to express something—or one's self.

Here, successful studies present a demonstration. Since they cannot be misread or misunderstood, they prove understanding both of the principle involved and of the materials to be manipulated. (See plates IV-1 and IV-3.)

It should be clear that, with these exercises and all others to follow, whether or not we arrive at a pleasant or harmonious color combination is unimportant.

Precision and clean execution are required for all finished studies. To avoid destroying the desired effect, small pieces of paper on small grounds should not be used.

Arrangements such as the one shown below disguise the desired effect and lead to confusion:

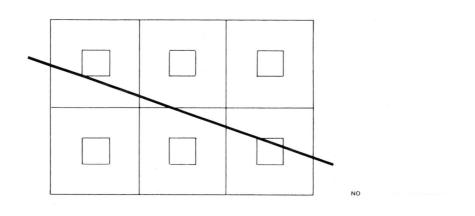

Such studies shown separately in pairs may demonstrate clearly the desired effects. But interlocked in the tile pattern opposite, their illusional effects annul each other because of:

- a) The simultaneous influence from too many directions from left and right, and above and below;
- b) The unfavorable distribution of area between the influencing and the influenced color.

Consequently, such presentation lacks both sight and insight.

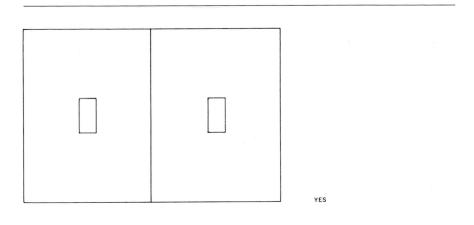

Lighter and / or darker light intensity, lightness

If one is not able to distinguish the difference between a higher tone and a lower tone, one probably should not make music.

If a parallel conclusion were to be applied to color, almost everyone would prove incompetent for its proper use. <u>Very few are able to distinguish</u> higher and lower light intensity (usually called higher and lower value) between different hues. This is true despite our daily reading of numerous black-and-white pictures.

Since the discovery of photography and particularly since the development of photomechanical reproduction processes, we are exposed—more and more every day—to pictures from all over the world, the world seen and unseen, visible and invisible.

These pictures, which are predominantly "black and white," are printed in only 1 black on a white ground. Visually, however, these pictures consist of grey shades of the finest gradations between the poles of black and white. These shades penetrate each other in varying degrees.

With the tremendous increase in pictorial information —through newspapers, magazines, books—we receive a training in the reading of lighter and darker tones of grey as has never before existed. With the growing interest in color photography and color reproduction, a parallel training in the reading of lighter and darker color is on the way.

However, it is still true that only a minority can distinguish the lighter from the darker within close intervals when obscured by contrasting hues or by different color intensities.

In order to correct a prejudice common among painters and designers that they belong to that minority we have the students test themselves. We confront them with several pairs of color, from which they are to select and to record which color in a pair is the darker. The darker one, it is explained, is visually the heavier one, or the one containing more black, or less white. It should be mentioned that the students are encouraged to abstain from making a judgment in any case of doubt. It may also demonstrate that not voting can have a positive meaning.

Though there have always been advanced painting students in the basic color class, the result of this test has remained constant for a number of years: 60% of the answers are wrong and only 40% are right, not counting the undecided cases.

By this experience we are led to the next task: To find colors about which we cannot say immediately which is the lighter or darker. These colors are collected and pasted in pairs, and observed again and again until their light-dark relationship is clearly recognized.

In cases where a decision seems impossible, an after-image effect may be helpful. 2 color sheets are put on top of each other in this way:

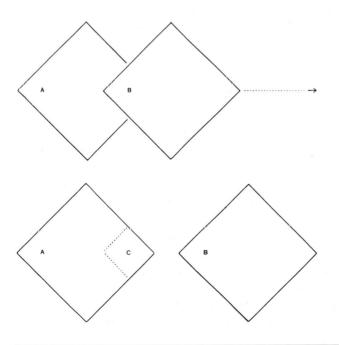

Focus longer than the eye wants to on the covering corner (B) of the upper paper and then quickly remove this upper sheet. If area (C) now appears lighter than area (A), then the upper paper is the darker—and vice versa. After this, repeat the experiment with the papers in reverse order. Frequently only 1 of the 2 reversed comparisons reveals the true relationship.

The usual results (60% wrong) are disillusioning as well as revealing. Voting for the wrong color often needs cover or compensation; also, the disappointment of wrong answers encourages doubts. The doubts often are directed, not against one's own judgment, but against the competence of the teacher: are his answers the right ones?

As the test is to prove whether one has a trained eye or not, the pairs of color presented for discrimination are not easy to decipher. Within the pairs there is no equal light intensity because the conclusive question to be expected from a class is: are there equal light values within these couples? The answer is No.

Another unavoidable question is: will a photograph of these colors reveal their true relationship and thus give the final proof? The answer again is No.

This answer will remain true for black-and-white as well as color photographs, because the sensitivity and consequently the registration of the retina of an eye is different from the sensitivity and registration of a photographic film.

Normally, black-and-white photography registers all lights lighter and all darks darker than the more adjustable eye perceives them. The eye also distinguishes better the so-called middle greys, which in photography often are flattened if not lost.

As an example we showed our class 2 different reproductions of the same Ensor painting, "Masks Confronting Death," of 1888. The first appeared in the catalogue of an Ensor exhibition, the other in a newspaper report on the same exhibition.

Higher Contrast

The first, the larger and more official reproduction, in very fine screen on coated paper, presumably would be considered more representative than the second, smaller reproduction in a coarser screen and on the cheapest paper.

But the latter was not only much more correct in its whole tonality; it also showed clearly 1 more mask, face, or head which the more expensive, so-called high-key reproduction blotted out entirely—a small but complete frontal face, lighter than all the others and separated from them, near the left picture edge.

This shows what a higher key in light can lose in photography.

The greatest advantage the eye has over photography is its scotopic seeing in addition to its photopic seeing. The former means, briefly, the retinal adjustment to lower light conditions.

Color photography deviates still more from eye vision than black-and-white photography. Blue and red are overemphasized to such an extent that their brightness is exaggerated. Though this may flatter public taste, the result is a loss in finer nuances and in delicate relationships. Whites rarely appear white but usually look greenish. This makes color slides of Mondrian paintings unbearable.

Gradation studies-new presentations

With the experience that often we are unsure and thus unable to distinguish between lighter and darker in color, it appears appropriate, even necessary, to develop a more discriminating sensitivity. To this end, we study gradation by producing so-called grey steps, grey scales, grey ladders. These demonstrate a gradual stepping up or down between white and black, between lighter and darker.

For such exercises, we first collect as many greys in paper as possible, and preferably independent of commercial grey sets, which usually offer a too limited choice, or, worse, unequal steps. Rich sources for many paper greys are black-and-white reproductions from popular magazines. Selecting from them smaller and larger areas of as many greys as possible, we will be taught first that photography registers and measures light and dark differently from our eyes. That it turns darks darker and lights lighter means, besides a generalization toward the polar contrasts, a loss of the visually more interesting middle greys. Thus, such reproductions confront us with a dominance of very heavy and very light greys, and a consequent scarcity of middle greys.

These cutouts are to be arranged in gradations as described. The softer the steps appear, and the more equal the steps are, the more valuable and convincing the study. As any lines or empty spaces between the steps interfere with a direct comparison, such separating in-betweens prove nonsensical. We also reject the still-recommended but misleading stepping-up of the thin layers of water colors or India ink, as explained in Chapter xx. In order to avoid such mistakes, and also any mechanical repetition of the too-familiar illustrations of color books, we aim at a more creative, more challenging, more instructive presentation. Thus we subdivide and mount our grey scales to show new interactions, particularly between graduating and non-graduating greys, and vice versa. (See plate v-1.)

Color intensity-brightness

After the study of "Lighter or Darker" and with some training in gradation studies, one can expect to come to an agreement on different light intensities.

However, when it comes to color intensity (brightness), occasionally one may find agreement among a few people but hardly within a large group such as a class. As "gentlemen prefer blondes," so everyone has preference for certain colors and prejudices against others. This applies to color combinations as well. It seems good that we are of different tastes.

As it is with people in our daily life, so it is with color.

We change, correct, or reverse our opinions about colors, and this change of opinion may shift forth and back.

Therefore, we try to recognize our preferences and our aversions what colors dominate in our work; what colors, on the other hand, are rejected, disliked, or of no appeal. Usually a special effort in using disliked colors ends with our falling in love with them.

The exercise in color intensity consists of sorting all possible shades and tints within a hue. From these is chosen the most typical hue (the bluest blue, the greenest green, etc.) and it is placed within the group accordingly. (See plate v-3.)

1 color appears as 2 looking like the reversed grounds

Having presented, in the previous problem, a very detailed explanation of a step-by-step method of teaching and learning, the following problem permits a briefer description.

With the first exercise in color interaction we make

color look like 2, or, what means the same,
 colors look like 4. The next step is to make
 colors look like 2, or, describing it as in the previous task,
 color is to show 2 faces which refer to the 2 colors
 of the reversed grounds,

or, the changed color is to echo the 2 changing ones.

After showing a few examples, the task of producing similar effects is introduced with the question:

Which color will play simultaneously the roles of the 2 colors of the 2 reciprocal grounds?

The first class exhibition of preliminary solutions shows that most of the trial colors selected appear closer to one ground than to the other.

However, when one tries to find a color that is equally close or equally distant from both grounds, one will discover that even a large collection of color paper (even that of the entire class) may not provide the fitting tone.

Then, instead of pushing the in-between color to one or the other side, we must consider changing 1 or both of the grounds, either moving closer to or more distant from the in-between color. (See diagram.)

After repeated trials it must be concluded that the only fitting color is the one which is topologically in the middle of the colors of the 2 grounds.

Ť		
	LJ	

The task is to find this middle color.

This is relatively easy when the 2 grounds are of the same hue, as with a lighter and a darker green ground, or with a lighter and a darker violet ground.

It is a more challenging task to find the middle color between 2 different hues but it is particularly interesting when the 2 grounds are of opposing (complementary) colors. (See plates VI-3 and VI-4.)

² different colors look alike— subtraction of color

The fact that one and the same color can perform many different roles is well known and is consciously applied.

Less well known is the possibility in the previous exercise of giving a color the look of reversed grounds.

Still more exciting is the next task, the reverse of the first: to make 2 different colors look alike.

In the first exercise it was learned that the more different the grounds, the stronger is their changing influence.

It has been seen that color differences are caused by 2 factors: by hue and by light, and in most cases by both at the same time.

Recognizing this, one is able to "push" light and/or hue, by the use of contrasts, away from their first appearance toward the opposite qualities. Since this amounts virtually to adding opposite qualities, it follows that one might achieve parallel effects by subtracting those qualities not desired.

This new experience can be achieved first by observing 3 small samples of 3 reds on a white ground. They will appear first of all-red.

Then when the 3 reds are placed on a ground of another red their differences, which are differences of hue as well as of light, will become more obvious.

Third, when placed on a red ground equal to 1 of the 3 samples, only 2 of the reds will "show," and the lost one is absorbed-subtracted. Repeated similar experiments with adjacent colors will show that any ground subtracts its own hue from colors which it carries and therefore influences.

Additional experiments with light colors on light grounds and dark colors on dark grounds prove that the light of a ground subtracts in the same way that its hue does.

From this, it follows that any diversion among colors in hue as well as in light-dark relationship can be reduced if not obliterated visually on grounds of equal qualities.

Such studies provide a broad training in analytical comparison and usually evoke surprising results, leading the student to an intense study of color. (See plates VII-4, VII-5, and VII-7.)

Why color deception? after-image, simultaneous contrast

For a better understanding of why colors read differently from what they really (physically) are, we show now the cause of most color illusions.

In order to prepare for the second part of this demonstration, cut out in red and white color paper 2 equal circles (of ca. 3-inch diameter) and mark their centers with a small black dot. (See plate VIII-2.)

Then paste them—horizontally related—the red circle to the left and the white one to the right, on the blackboard or a piece of black paper or black cardboard, ca. 10 inches high and 20 inches long, with about equal amounts of black before, between, and after the 2 circles.

Now, by staring steadily at the marked center of the red circle (up to half a minute) one soon discovers how difficult it is to keep the eye fixed on a point. After a while, moon-sickle shapes appear, moving along the circle's periphery. In spite of this, one must continue to focus on the red center point in order to assure the desired experience. Then quickly shift the focus to the center of the white circle.

From the class one usually hears noises which indicate surprise or astonishment. This happens because all normal eyes suddenly see green or blue-green instead of white. This green is the complementary color of red or red-orange. The phenomenon of seeing green (in this case) instead of white is called after-image, or simultaneous contrast. A plausible explanation:

One theory maintains that the nerve ends on the human retina (rods and cones) are tuned to receive any of the 3 primary colors (red, yellow,

or blue), which constitute all colors. *Eye Produces an illusion of the complement* Staring at red will fatigue the red-sensitive parts, so that with a sudden shift to white (which again consists of red, yellow, and blue), only the mixture of yellow and blue occurs. And this is green, the complement of red.

The fact that the after-image or simultaneous contrast is a psycho-physiological phenomenon should prove that no normal eye, not even the most trained one, is foolproof against color deception.

He who claims to see colors independent of their illusionary changes fools only himself, and no one else.

IX Color mixture in paper illusion of transparence

It is obvious that in working with color paper there is no way of mixing the colors mechanically, as paint and pigment permit, and as they invite one to do on a palette or in a container.

Though this may first appear as a handicap, it is actually a challenge to study color mixture in our imagination, that is, so to say, with closed eyes.

Starting with the simple and well-known fact that blue and yellow when mixed produce green, a blue and yellow are selected and held next to each other. One tries to imagine what kind of green would result from a mixture of these 2 colors. Then a paper is selected appropriate to this imagined mixture.

In order to find out whether the "thought-out" mixture is acceptable believable—convincing—the 3 colors (2 "color parents" and 1 "color descendant") are placed in 3 equal rectangles as follows:

Blue horizontally (1), green vertically (2) so that its upper part overlaps the blue. The yellow is put on top of the green (3) so that its top edge coincides with the bottom edge of the blue.

In such placement, the green will be the "in-between" of the other colors and thus their mixture.

After the class has found several believable mixtures, these are collected for an exhibition (most practically, on the floor) and the most convincing ones are selected. Some are usually more successful than others. The class states their merits and shortcomings and suggests possible corrections and improvements.

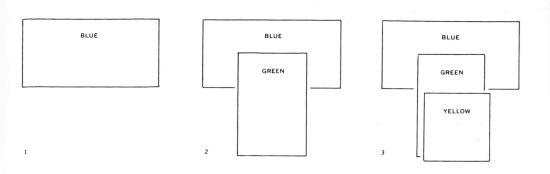

Mixed Colors = "transparency?" Tor Middle, In Botween

By means of the exhibition, the students will be reminded that there are many blues and many yellows, and will conclude that there are innumerable mixtures descending from them. It is obvious that any 2 colors can produce many mixtures.

In addition to the illusion of mixture, another deception will be recognized that, in an illusionary mixture in paper, 1 color seems to show through the other. The "mixture" paper, therefore, loses its opacity and appears transparent or translucent.

In order to make the eye read this double illusion of mixture and of transparence, the colors must be placed in overlapping shapes.

In the drawing on page 26 the hatched parts belong to each of the overlapping shapes and are therefore the logical place for the mixture.

After simple mixtures, such as blue and yellow producing green—red and blue producing violet—black and white producing grey—less common pairs, such as pink and ochre, present a further challenge.

For a more intensive experience, keep the area of the mixture larger than those of the 2 mixing ones. (See plate IX-1.)

If we name 2 mixture parents A and B, and their mixture C, then our first task is to find C's, which are mixtures of A and B, another task will be ""B's, conditioned by A"C, or, a third task, ""A's ""B"C.

This invites one to draw conclusions backward, that is, to guess—from a mixture and 1 mixture parent—the other mixture parent.

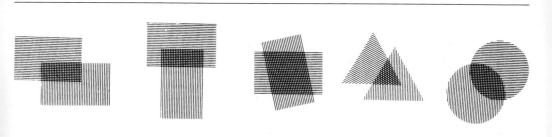

Factual mixtures additive and subtractive

Though the color class (as a rule) abstains from the use of colorants (meaning pigments and paints) for reasons explained before, the color studies in paper are related to the actual use of paint as often as possible.

Therefore, after the introductory studies of mixture as illusion, factual mixing is analyzed. There are 2 kinds of physical mixture:

- a) Direct mixture of projected light,
- b) Indirect mixture of reflected light.
- a) Color light, or direct color, probably is most familiar
 through its practical application in theater and advertising.
 The scientific analysis of the physical qualities (wave length, etc.)
 is not the problem of the colorist; it is the concern of the physicist.
 When he mixes his colors, he projects them on a screen,
 1 on top of or overlapping the other.
 In any such mixture where there is overlapping,
 it will be obvious that every one of these mixtures
 is lighter than any of the mixture parents.
 By means of a prismatic lens, the physicist easily demonstrates
 that the color spectrum of the rainbow is a dispersion of the white sunlight.
 With this he proves also that the sum of all colors in light is white.
 This demonstrates an additive mixture.

b) When pigment or paint is mixed on a palette or in a container it is seen by the eye as reflected light. This mixing will never result in white as the sum of colors.

> On the contrary, the more color that is mixed, the more the mixture approaches a dark grey leaning toward black. This we call subtractive mixture. Also, the psychologist, who mixes colors of reflecting colorants

optically on the rotating wheel, is not able to arrive at mixtures

lighter than the lighter color parent of the mixture.

As optical mixture usually means less loss of light than mechanical mixture, the psychologist's sum of all his colors normally approaches a middle grey instead of the dark grey of the painter.

The conclusion is: mixtures gain light only in direct color, as in (a), whereas mixtures of reflected colors lose light, as in (b).

Though direct color or color light normally is not the medium of the colorist, examples of this effect should be indicated. Additive and subtractive mixtures should be made in appropriate studies in transparence illusions. These will provide a preparatory training for studies to follow.

For the sake of simplicity and to avoid difficult complications, these mixtures should be done in 1 thin color mixing preferably with white (or black), and then reversing the first study. (See plate x-1.)

Sample arrangements:

AND REVERSED

AND REVERSED

XI Transparence and space-illusion Color boundaries and plastic action

A study of color mixture in paper leads to 3 important discoveries.

First, under normal conditions, a subtractive mixture is not as light as the lighter of the color parents nor as dark as the darker one. Furthermore, the mixture is reciprocally neither higher nor lower in color intensity than the color parents.

Second, a mixture depends upon the proportion in which colors are mixed. Varying amounts of blue and yellow, for instance, define the character of a green. This indicates a possible predominance of 1 color parent.

Third, when 1 color is read as appearing above or below another in the transparence studies, a third deception is recognized—space-illusion.

This leads to the next task:

To produce different illusionary mixtures which derive from 1 pair of parent colors. If the parents are again a blue and a yellow, some greens will be found with yellow dominance imbalance of granted and others with blue dominance. With more mixing experience colors it will become apparent that the nearness of a mixture to one side (let us say yellow) necessitates distance from the opposite side (in this case blue).

After having found several mixtures of different pairs of parent colors, we then try to find the most significant and the most difficult mixture —the middle mixture. Topographically, this middle mixture demands precise placement, and therefore additional means of measure are necessary.

Since the middle mixture presupposes equidistance from the color parents, it therefore depends equally upon the absence of any predominance of the color parents. No weight to either side

Here, the following diagrams may be helpful:

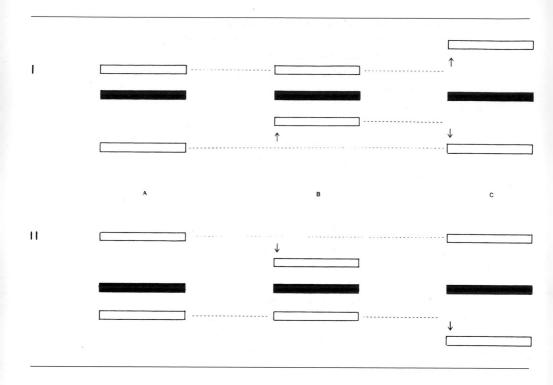

Of the 3 bars in each diagram, the black bar represents an in-between color, the mixture in question; that is, the one to be "equidistant" from the accompanying white bars. The latter represent possible color parents for a color mixture. The upper bar represents a lighter (higher) color, and the lower bar represents a deeper (heavier) color.

In IA the mixture line is nearer to the upper line, and is therefore too light; in IIA the opposite happens. The middle color-to-be is nearer to the lower bar and consequently is too dark. For the necessary corrections in IA, we must look for a lower (darker) middle, and in IIA for a higher (lighter) middle.

Unfortunately, those higher and lower tones are often not available. In such cases, we should try to adjust the outer (upper or lower) colors —instead of the middle color—in order to exercise another way of correct placement. Thus, in IB the lower bar is lifted from the dotted line, e.g. a lighter color is chosen; in IIB the upper bar is lowered. In c similar changes take place but in an opposite direction from B. Comparing groups B and C will demonstrate that correct arrangements may become closer to or more distant from the middle color.

Such efforts forth and back in our search for a middle colorto be specific, for a middle placement-provide through continued comparison a thorough visual training: "thinking in situations."

Besides an explanation of the above diagrams on the blackboard, a physical demonstration in space may clarify this further. When discussing the first trial studies, exhibited on the floor with the students standing around them, 2 hands held horizontally 1 above the other may act as the 2 outer colors. And a third hand held between them may demonstrate various possibilities of color selection and placement, either by moving the hand indicating the middle color up or down, or by moving the outer hands up and / or down, singly or together.

With a more developed sensitivity for mixtures, it will be discovered that distance, nearness, and equidistance between colors can be recognized through the boundaries between the mixture and the mixture parents.

By exercising comparison and distinction of color boundaries, a new and important measure is gained for the reading of the plastic action of color, that is, for the spatial organization of color. Color &

Since softer boundaries disclose nearness implying connection, harder boundaries indicate distance, separation.

In both interpretations colors are placed above or below each other, f_{UGC} there or in front of or behind each other. There are readed above or below each other, or in front of or behind each other. They are read as here and there, as over, and beyond there, and therefore in space.

All this seems to change with colors producing middle mixtures. Sometimes they appear as if meeting within a 2-dimensional plane; at other times they can be read-interchangeably-as higher or lower than the mixture.

Distance read

Thus, with a middle mixture all boundaries are equally soft or hard. As a consequence, a middle mixture appears frontal, as a color by itself. This is comparable to the reading of any symmetrical order and the middle mixture will behave unspatially, unless its own shape, or surrounding shapes, decides differently. (See plates XI-1 and XI-3.)

Such a study, or a similar recognition, in my opinion, led Cézanne to his unique and new articulation in painting. He was the first to develop color areas which produce both distinct and indistinct endings —areas connected and unconnected—areas with and without boundaries as means of plastic organization.

And, in order to prevent evenly painted areas from looking flat and frontal, he used emphasized borders sparingly, mainly where he needed a spatial separation from adjacent color areas.

XII Optical mixture—after-image revised

XIII The Bezold Effect

In contrast to after-image, so far the main concern of our studies, here is another very different color illusion called "optical mixture." Instead of 2 (or more) colors changing each other, "pulling" or "pushing" each other into different appearances (toward both greater difference and greater similarity), here 2 colors (or more), perceived simultaneously, are seen combined and thus merged into 1 new color. In this process, the 2 original colors are first annulled and made invisible, and then replaced by a substitute called optical mixture.

a substitute called optical mixture. Subfic mixes & up plications of colori not bold, harsh mixes From the Impressionist painters we have learned that they never presented, let us say, green by itself. Instead of using green paint mixed mechanically from yellow and blue, they applied yellow and blue unmixed in small dots, so that they became mixed only in our perception—as an impression. That the dots mentioned were small indicates that this effect depends on size and on distance.

The discovery of the mixing of colors in our perception led in the last century not only to the new painting technique of the Impressionists, and particularly of the Pointillists, but also to the invention of new photomechanical reproduction techniques, the 3- and 4-color process for paintings, and the halftone process for black-and-white pictures. In the first case, 3 or 4 color plates subdivided into tiny printing dots mix to innumerable color shades and tints. In the second case, a plate for black also subdivided by a screen in tiny dots mixes with the white paper in just as innumerable tones of white—grey—black.

There is a special kind of optical mixture, the Bezold Effect, named after its discoverer, Wilhelm von Bezold (1837–1907). He recognized this effect when searching for a method through which he could change the color combinations of his rug designs entirely by adding or changing 1 color only. Apparently, there is so far no clear recognition of the optical-perceptual conditions involved. (See plates XIII-1, XIII-2, and XIII-3.)

XIV Color intervals and transformation

The tune of "Good morning to you" consists of 4 tones. It can be sung in a high soprano, a low basso, and in all in-between voices, as well as on many levels and in many keys. It can be played on innumerable instruments.

In all possible ways of performance, this melody will keep its character and it will be recognized instantly.

tonal range = in buth music & art Why? The intervals of the 4 tones, that is, their acoustical constellation (again comparable with a topographical relationship), remains the same.

Although it is not common practice, one can also speak of intervals between colors.

Colors and hues are defined, as are tones in music, by wave length.

Any color (shade or tint) always has 2 decisive characteristics: color intensity (brightness) and light intensity (lightness). Therefore, color intervals also have this double-sidedness, this duality.

As has been stated before, after some training one might easily agree on light relationship, that is, which of 2 colors is lighter and which is darker. However, there is rarely agreement on color intensity, that is, which among a number of reds is the reddest red. For this reason the interval transformation exercise is concerned mainly

with light intensity.

Intensity as superation maybe?

To prepare a basic exercise in color transformation, combine 4 equal squares of different colors to make 1 larger square. Within this grouping of 4 squares, the lighter will differentiate from the heavier, darker color. Therefore, the squares will connect with each other or separate according to contrast and affinity, as vertical, horizontal, or diagonal pairs, or as a trio forming an angle, embracing or opposing a fourth square. (See diagrams.)

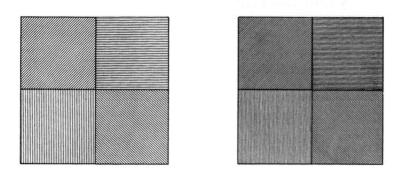

The task is to transfer these specific relationships to a higher or lower key within 2 or more groups of equally large rectangles. Of course, if the first group contains the darkest color available, one cannot go lower. Similarly, the lightest white would not permit any transference to a higher key.

It is rarely possible to retain the first 4 rectangles selected. Frequently it will be impossible to find 4 colors equally raised or lowered when compared with the original set. If so, the original set should be changed in order to transfer more successfully.

In a successful study, both groups should show equal relationships in equal placement, as a constellation. Then, as with the study of varying mixtures, the boundaries between the 4 rectangles will also appear similar in both groups.

Again, the aim of this exercise is not to present a pleasant, perhaps harmonious look, but to present a study aiming at one distinct relationship— parallel intervals.

How do we prove such similarity, such parallelism? As has been learned from gradation studies done at the beginning, it is poor "psychological engineering" to present the gradation steps unconnected, that is, separated by black lines. Similarly, in the transformation exercise it is hard to compare the boundaries within the original group of 4 rectangles with the raised or lowered boundaries in the second, separated group. The only way in which the 2 groups can be compared easily and accurately is to superimpose 1 group on the other.

For this purpose we cut from the center of the first group a small rectangle and exchange it with an equally shaped and placed small rectangle of the second group. (See diagrams below.)

Immediately, the superimposed rectangles will show whether the stepping up or down within 1 group corresponds with the stepping in the other. A further comparison should be made between each small rectangle and the larger group beneath it. The sample studies will also show that the boundaries provide an important means of comparison.

Usually, as shown, a lower color tetrachord is transferred to a higher key, or opposite; one may also break with habit and try to make a low color constellation still lower, or a high one still higher. (See plates xIV-1, XIV-2, and XIV-3.)

By keeping the stepping—up or down—small, a special effect of transparence is achieved called film color, to be described in Chapter XVII.

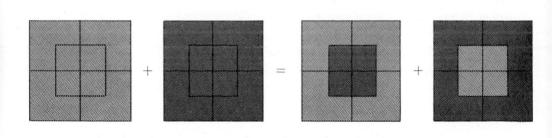

XV The middle mixture again— intersecting colors

Our studies of illusionary transparence have shown how difficult it is to find a middle mixture.

A true middle mixture is distinguished by being equidistant -in light and in huefrom either mixture parent.

Unfortunately, for an untrained eye, it is hard to recognize such equidistance.

We have seen that the color boundaries between the mixing color and the mixed one have proved to be helpful measures.

The purpose of the new problem, intersecting colors, is to show and to produce a certain constellation by which even an untrained eye will recognize within a mixture not only the constituents but also their respective amounts within that mixture.

For an initial experience in this direction find 3 equally large sheets of 1 red in 3 shades, a light red, the same red darker, and the almost always elusive middle mixture of these reds. Or, if not available in red, take any other color providing a lighter, a middle, and a darker shade or tint. (See diagrams, next page.)

Place them adjacent to one another,

with the lighter red to the left and overlapped by the edge of the middle red; then place the dark red on top of the middle red, allowing only a narrow strip of the middlc rcd (about ¼ inch wide) to remain visible.

Then, very slowly, pull the dark sheet to the right, gradually making the narrow strip of the middle red wider.

By staring at the middle red, observe that the wider it grows, the more it appears not as 1 but as 2 colors, becoming lighter and lighter at the right edge, and, at the same time, darker and darker at the left edge.

By doing this repeatedly, it becomes obvious that the middle color plays the role of both mixture parents, presenting them in reversed placement.

Repeating this experience with other colors will show that in a true middle mixture the mixture parents will appear in equal amounts.

In most cases, however, the larger amount of 1 of the 2 colors reveals its predominance.

Such exercises are exciting as well as revealing, particularly when extended to different and opposing colors.

These exercises remind us that the basic after-image presentation, the simultaneous contrast, is the cause of all color deception.

Whereas the first measuring of middle mixtures led us to space illusion through connecting and separating boundaries, this direct reading of the mixture constituents leads us to a new deception: an illusion of volume.

It is an effect we have seen in the channelings of the Doric column and is called a fluting effect. (See plate xv-2.)

XVI Color juxtaposition harmony—quantity

Harmony

Color systems usually lead to the conclusion that certain constellations within a system provide color harmony. They indicate that this is mainly the aim and the end of color combination, of color juxtaposition.

As harmony and harmonizing is also a concern of music, so a parallelism of effect between tone combinations and color combinations seems unavoidable and appropriate. Although a comparison of composed colors with composed tones is very challenging, it should be mentioned that, while it can be helpful, it is often misleading.

This is because different basic conditions of these media result in different behavior.

Tones appear placed and directed predominantly in time from <u>before</u> to <u>now</u> to <u>later</u>.

Their juxtaposition in a musical composition is perceived within a prescribed sequence only. Vertically, so to say, 1 tone, or several simultaneously, sound for a varying but restricted length of time. Horizontally, the tones follow each other, perhaps not in a straight line, but of necessity in a prescribed order and only in 1 direction—forward. Tones heard earlier fade, and those farther back disappear, vanish. We do not hear them backward.

Colors appear connected predominantly in space. Therefore, as constellations they can be seen in any direction and at any speed. And as they remain, we can return to them repeatedly and in many ways. This remaining and not remaining, or vanishing and not vanishing, shows only 1 essential difference between the fields of tone and color.

The accuracy of perception in one field is matched by the durability of retention in the other, demonstrating a curious reversal in visual and auditory memory.

Tone juxtapositions can be defined by their acoustical relationship and thus measured precisely by wave length.

Consequently, a graphic registration of tones in musical composition has been developed.

Color, also, can be measured, at least to some extent, and particularly so when it is presented as direct color as the physicist registers it, by optical wave length.

Reflected color, however, coming from paint and pigment —our main medium—is much more difficult to define.

When analyzed with an electrical spectrograph reflected color shows that it contains all visible wave lengths. Therefore, any reflected color—not just white — consists of all other colors.

This many-sided relationship between colors is clearly visible in the plates of a 4-color reproduction, when singly shown, because each of the 4 plates, although presenting only 1 color, shows a complete picture.

Color, when practically applied, not only appears in uncountable shades and tints, but is additionally characterized by shape and size, by recurrence and placement, and so on, of which particularly shape and size are not directly applicable to tones. All this may signify why any color composition naturally defies such diagrammatic registration as notation in music and choreography in dance.

With regard to constellation, tone intervals, such as third, fifth, and octave, differentiate exact vertical distance. We say "vertical" probably because tones are described as low and high. Slide deflections (aberrations), such as in flat and sharp, remain equally precise. Color terms which could be considered parallel to tone intervals are complementaries, split complementaries, triads, tetrads, and octads.

Though these characterize distance and constellation within color systems, their deflections, such as incomplete triads and incomplete tetrads, indicate that their measure is only arbitrary.

Significantly, complementaries, though they are the basic color contrast or interval, are topographically quite vague.

In principle, a complementary is a color accompanied by its after-image.

However, the complement of a specific color, when placed in different systems, will look different.

Similarly, a triad or tetrad of one system will hardly fit into another system.

Usually, illustrations of harmonic color constellations which derive from authoritative systems look pleasant, beautiful, and thus convincing. But it should not be overlooked that they are usually presented in a most theoretical and least practicable manner, because normally all harmony members appear in the same quantity and the same shape, as well as in the same number (just once) and sometimes even in similar light intensity.

Such outer equalization may unify them, but at the expense of the more important inner relatedness—namely, as color only.

When applied in practice, these harmony sets appear changed. In addition to quantity, form, and recurrence, wider aspects exert still more changing influences. These are:

> Changed and changing light—and, even worse, several simultaneous lights; reflection of lights and of colors; direction and sequence of reading; presentation in varying materials; constant or altering juxtaposition of related and unrelated objects.

With these and other visual displacements, it should not be a surprise that the sympathetic effect of the original "ideal" color combination often appears changed, lost, and reversed.

Observe the interior and exterior, the furniture and textile decoration following such color schemes, as well as commercialized color "suggestions" for innumerable do-it-yourselves.

Our conclusion: we may forget for a while those rules of thumb of complementaries, whether complete or "split," and of triads and tetrads as well.

They are worn out.

Second, no mechanical color system is flexible enough to precalculate the manifold changing factors, as named before, in a single prescribed recipe.

Good painting, good coloring, is comparable to good cooking. Even a good cooking recipe demands tasting and repeated tasting while it is being followed.

And the best tasting still depends on a cook with taste.

By giving up preference for harmony, we accept dissonance to be as desirable as consonance.

In searching for new color organization—color design we have come to think that quantity, intensity, or weight, as principles of study, can lead similarly to illusions, to new relationships, to different measurements, to other systems, as do transparence, space, and intersection. Besides a balance through color harmony, which is comparable to symmetry, there is equilibrium possible between color tensions, related to a more dynamic asymmetry.

Again: knowledge and its application is not our aim; instead, it is flexible imagination, discovery, invention—taste.

With this study of color effects, that is, of color deception, a special interest in quantity—amount as well as recurrence has developed.

Quantity

Although quantity and quality often are considered disparate, in art and music they appear closely related. We may even hear, "Quantity is a quality," because here quantity not only designates amounts, as of weight or number, but also is a means of underlining, of pronouncement, and a means of equilibrium, of balance.

One who particularly recognized the latter was Schopenhauer. When he tried to improve Goethe's 6-part color circle—to Goethe's dismay he changed the previous presentation of 6 equal areas to decidedly different quantities.

Thus yellow, the lightest color, appears in the smaller amount, and its opposite, violet, as the darkest, in the largest amount. He first allotted 3 equal thirds of a color ring to the 3 pairs of opposites—yellow & violet—blue & orange—red & green. Second, he subdivided those thirds, for the same order of pairs, in $\frac{1}{4} + \frac{3}{4} - \frac{1}{3} + \frac{3}{2} - \frac{1}{2} + \frac{1}{2}$. These figures in fractions of 12ths (relatively 36ths) are proportionate to 3:9-4:8-6:6 equal parts. When seen in a color circle, from yellow around to green, they present the following quantities: 3:4:6:9:8:6.

The 2 basic quantity questions, how much and how often, distinguish 2 kinds of quantity: 1 of size—extension in area—and 1 of recurrence—extension in number. Both measurements concern predominance and emphasis. They establish weight in space—and weight in time. Such considerations are both the source and result of our quantity studies in which 4 colors usually appear in 4 different juxtapositions, so different that all 4 studies appear as unrelated as possible.

And thus they present changes in climate or temperature, in tempo or rhythm-that is, changes of atmosphere or mood, so that the factual contents (the same 4 colors) are hidden or, better, Weight of culor provides different Flacors hardly recognizable.

To use a theatrical parallel:

A set of 4 colors is to be considered—singly as "actors," together as "cast." They are to be presented in 4 different arrangements-as "performances."

Although they remain unchanged in hue and light, in "character," and appear in an unchanging outer frame, the "stage," they are to produce 4 different "scenes" or "plays," each to be so different that one and the same set of colors will be seen as 4 different sets, presented by 4 different casts.

And all this can be achieved mainly through changes in quantity which result in shifts of dominance, of recurrence, and consequently of placement.

The essential question: which group of colors is ready to lose its identity as a cast?

A parallel question: which distribution of appearance (quantities of space, time, and weight) protects, disguises recognition of the same color cast?

Such quantity studies have taught us to believe that, independent of harmony rules, any color "goes" or "works" with any other color, presupposing that their quantities are appropriate. We feel fortunate that so far there are no comprehensive rules for such aims. (See plates XVI-2 and XVI-3.) Fuded colors or less

Here we may point to a discovery made by a few contemporary painters, that the increase in amount of a color-not merely in size of canvasvisually reduces distance. As a consequence, it often produces nearnessmeaning intimacy-and respect.

XVII Film color and volume color— 2 natural effects

Usually, we think of an apple as being red. This is not the same red as that of a cherry or tomato. A lemon is yellow and an orange is like its name. Bricks vary from beige to yellow to orange, and from ochre to brown to deep violet. Foliage appears in innumerable shades of green. In all these cases the colors named are surface colors.

In a very different way, distant mountains appear uniformly blue, no matter whether covered with green trecs or consisting of earth and rocks. The sun is glaring white in daytime, but is full red at sunset. The white ceilings of houses surrounded by lawns or the white-painted eaves of a roof on a sunny day appear in bright green, which is reflected from the grass on the ground. All these cases present film colors. Farther away, more of a They appear as a thin, transparent, translucent layer between the eye deception

duse up

and an object, independent of the object's surface color. (See plate XVII-1.)

For a very different color effect compare the coffee in a cup with the coffee in the stem of a percolator or with the coffee in a silex glass. It is easy to discover that, though all 3 containers hold the same coffee, the containers show this coffee in 3 different browns: lightest in the stem, darker in the cup, darkest in the silex glass.

In the same way, tea will look lighter in a spoon than in a cup. Here we are dealing with volume color, which exists and is perceived in 3-dimensional fluids.

The water of a swimming pool with blue walls will look dyed with blue because of diffused reflection. Observing the white or blue steps within the water, we will discover that with each step down the blue of the water increases progressively, which presents a true volume color effect.

In Chapter xx it will be explained in what proportion the blue increases.

On the other hand, milk remains more or less the same white, no matter whether seen in a small or large container. Ink and oil paint behave in a similar way. This demonstrates that only transparent fluids present volume color.

In practice, most water colors are volume colors; several layers on top of each other increase the darkness, weight, and intensity of a color. Many aquarelles by Paul Klee demonstrate this. The reverse effect of increased lightness is seen in fingerpaintings.

In contrast to water colors, such media as oil paint, gouache, and pastel produce surface color. In most cases these paints do not change to any extent when applied in several layers.

A new medium with volume color effect is a photosensitive glass developed by Corning Glass Works. With increased exposure to certain rays, the translucent opalescent white within the glass increases. This results in a darkening of the whites with light passing through, but in a whiter white in reflected light.

A similar effect can be achieved in tracing paper. By looking through several layers against the light, the paper becomes darker. However, the same layers seen from the direction of the light will appear whiter. Since film color is not the result of physiological or psychological transformation, it is a physical phenomenon.

Both film color and volume color might be considered tricks of nature.

XVIII Free studies a challenge to imagination

The previous chapters deal mostly with tasks to be solved as class problems. Through them, all class members work in 1 direction only. This means they compete for the solution of 1 given problem at a time—that of a single color effect. Although the solutions may differ considerably, and especially so in their presentation, the work of the whole class appears unified.

Such studies aim at the development of observation, of differentiation. And this is particularly so through an inevitable constant comparison going on from student to student. As a consequence, these studies permit hardly any sclf-expression.

Thus, after such systematic exercises, a need for independent work arises, and free studies are encouraged. With them one may play with colors as one pleases, independent of exercises, independent of teachers and of other students.

Whereas the systematic problems occupy most of the class time and are finished afterward, the free studies are mostly homework, although they accompany the systematic studies almost from the beginning through the whole course.

The measure for evaluation of free studies is color relatedness. This means color juxtaposition in which color exists for color's sake, and therefore appears autonomous, and not merely as accompaniment to form, to shape. (See plates XVIII-3 and XVIII-9.)

Whether something "has color" or not is as hard to define verbally as are such questions as "what is music" or "what is musical."

The reproductions of free studies may indicate that the possibilities are endless. Since showing such samples may present a handicap, one might stimulate a beginning with thematic suggestions. Experience has taught that pairs of contrasts invoke a more distinct "meaning" and a more precise "reading."

First themes:			
gay — sad	young — old	major — mine	or
		0	
More daring:			
bright — dull	early – late	active — passi	ve
0	inter and a second s	public public	

These themes easily evoke discussions without end, since verbal reactions to the associations with color differ vastly from person to person.

Another stimulation is the problem of free studies in colors of a limited range. This means a restricted palette with, for instance, only contrasting or only adjacent colors, with selections of preferred or of disliked colors.

Any of these cases may aim for concord or discord.

Such and other restrictions usually result from a personal choice. More revealing, though harder to do, is the submission to selections by others. To work with the preference of others, to subordinate to someone else's palette or instrumentation, should be not only permitted but encouraged.

All this is to promote competition. And with that comes evaluation through comparison, which in the end means judgment. A strong challenge to a class is to work with 3 or 4 given colors selected by a teacher or student. This and a continued use of disliked colors will teach that preferences and dislikes—as in life so with color —usually result from prejudices, from lack of experience and insight.

Stripes-restricted juxtaposition

The first attempts to produce "free studies" usually result in the dominance of form or shape—and often very pronounced—over color.

This means, in most cases, that the outlines of the colors predominate. And, as visually the loudest, they are noticed first. Thus color appears of secondary interest, or only as accompaniment of shape. And this remains the normal result so long as the most decisive difference between color in paper and color in paint is not clearly recognized: colors in paper always consist of outspoken flat areas which present even colors reaching precisely from edge to edge. And the edges, by their very nature as uninterrupted endless contours, again advocate shape first.

For this reason, it is advisable to recommend torn papers for the beginning as they ordinarily offer looser and freer edges than cut papers.

More experience will lead to other means of softening or hardening color boundaries: smaller or greater contrasts of hue or of light; elemental or complex shapes; curved, straight, broken, or dotted lines.

By combining colors exclusively in stripes—that is, in stretched, narrow rectangles, all of the same length, varying only in width, and touching each other in full length we are led to overlook their rather equal shapes and to consider them almost shapeless.

As to placement of the stripes in horizontal or vertical direction, the latter appears more practicable. In a left-right and therefore sideward contact, color interaction usually is more easily comprehensible than within an up-down connection. And with this, our reading, connecting, grouping, and separating of the color stripes is easier.

The first task is to organize a large number of color stripes all narrow, of varying width but equal length, all vertical and touching each other, presenting only 4 colors—and only later to choose more or fewer colors.

The aim is to find an order in which, again relatively, all 4 colors are equally important, or, respectively, equally unimportant. In other words, none of the colors dominates. We say "relatively" in consideration of our individual attitude toward color, of our differing preferences for certain colors, and our dislikes of others. With a continuous alternation and recurrence of the 4 colors innumerable combinations and arrangements are possible. And the more they vary, the more they invite one to follow and to alter, with a constant change in connecting and dividing, overlapping and intersecting of seemingly many more than 4 colors.

We may consider such calculated juxtaposition as a symbol of community spirit, of "live and let live," of "equal rights for all," of mutual respect.

We should also encourage working with very different colors, so that light and color intensity may compete with and balance each other.

Such studies in stripes will readily remind us of textiles, and we may read and interpret them as fabrics of wool or cotton for various uses—of various color climates: from new to old, young to old, modern to old—related to peoples, times, and periods.

The purpose is to stimulate again a reading of the meaning of form, to invite verbal formulation of reaction to our associations with climates in color.

The second problem in color stripes aims at different results: dominance of 1 or more colors and broad areas is suggested; and either coordination and/or subordination is permitted.

More freedom in the number and the choice of colors and their extension and repetition is given. But restrictions to equal height and vertical partitioning remain, in order to avoid interference of form.

Whereas the first task has reminded us of striped textiles, here one may think of walls which are subdivided for structural, illusional, decorative purposes.

Though the second type of color studies in stripes leads usually to a more broad and bright palette in a positive reaction to the first, more restricted task it will again prove more profitable to aim with fewer means toward more action.

Fall leaf studies—an American discovery

Nowhere in the world, it seems to us, is the autumn foliage as brilliant in color as in the United States.

When leaves are collected, pressed, and dried—eventually varnished, even bleached, and sometimes also dyed or painted—they provide a most welcome enrichment of any color paper collection.

Collected in all varieties, in all possible shades of color —in large numbers for an easy exchange between students—they are both exciting to see and most stimulating to work with in free studies.

As studies show, these leaves work beautifully with color paper. They add innumerable tints and shades, with modulations and shapes that color papers do not have. They are used singly and in groups, in parts and combined again, repeated and reversed. Always keep in mind the color before the shape. Colorful leaves suit all ways of play and imagination for all kinds of order and placement. Therefore, they remain a favorite means of study.

Naturally, leaf studies are best done in their season, in autumn, at other times with prepared, preserved leaves which, of course, provide more subdued, less vivid colors.

As leaf studies arc frcc studies (usually done as homework), they are mentioned here under that title, as are studies in stripes. (See plates xxv-2 and xxv-6.)

XIX The Masters color instrumentation

It should be clear by now that our way of studying color does not start with the past—neither with works of the past nor with its theories.

As we begin principally with the material, color itself, and its action and interaction as registered in our minds, we practice first and mainly a study of ourselves.

Thus, we replace looking backward by looking first at ourselves and our surroundings, and replace retrospection with introspection.

Though our own development and our own work are closest to us, we see and appreciate encouragement from achievements of the past, and gratefully pay practical respect to their originators as often as the opportunity arises.

To honor the masters creatively is to compete with their attitude rather than with their results, to follow an artistic understanding of tradition—that is, to create, not to revive.

Therefore, in our study of the masters—both past and present there is, beyond mere retrospection and above verbal analysis, re-creating by re-performing their selection and presentation of color, their seeing and reading of color in other words, their giving a meaning to color.

Singing a tune and playing it on instruments even more, conducting several instruments provides more contact, more insight than merely hearing the tune. So cooking, normally and naturally, teaches more than reading recipes.

As a conclusion, we transfer paintings by masters into color paper, in order to identify their color instrumentation. Our aim is not production of precise replicas as copyists do in museums.

We try to give a general impression only as to climate, temperature, aroma, or sound of their work—not minute details.

The purpose of such study is neither to find out, for instance, whether ultramarine or cobalt blue was used, nor to register the factual content of the painter's palette.

It is another means of learning to develop a sensitive and critical eye for color relatedness.

The result of our transformation of paintings into color paper depends on several limitations. Naturally, in making them, we depend on reproductions.

In 3- and 4-color halftones, all colors are represented as optical mixtures of 3 or 4 standardized inks. These are mostly transparent, mixing not only with each other but also with the white paper underneath. That is to say, such reproductions are physically already of an absolutely different instrumentation.

The resulting false and misleading smoothness, even slickness or sweetness, and the dramatized brightness of so-called high-key color reproduction are easily and pleasantly counteracted and corrected by paper colors. This is the result of the opacity or visual weight of paper colors, and their varying density and volume.

As a rule, paintings transferred to color paper look painted; they do not look printed.

In the case of a Van Gogh and a Soutine, we easily regain the effect of dramatic execution.

And works of Matisse appear again as juxtaposition of flat color areas, opaque as well as untextured.

With such studies we submit to formulations of the past in order to provoke further comparisons of different attitudes, temperaments, mentalities, and personalities all for the sake of continued self-criticism and self-evaluation. This proclaims creative action ahead of retrospective reaction.

XX The Weber-Fechner Law the measure in mixture

In order to obtain a graduated scale of greys, M. E. Chevreul, the author of the famous book "The Laws of Contrast of Colour," gave the following instructions (from the English translation of 1868, page 5, paragraph 11):

> Upon a sheet of cardboard divided into ten stripes, each about a quarter of an inch broad, lay a uniform tint of India ink. As soon as it is dry, lay a second tint on all the stripes except the first. As soon as the second is dry, lay a third one on all the stripes except the first and second, and so on all the rest, so as to have ten flat tints gradually increasing in depth from the first to the last.

All this sounds quite convincing, so convincing that one wonders whether anyone has ever doubted that the result would be as promised whether anyone has ever followed these instructions, including M. Chevreul himself.

All this, of course, refers to volume color (see page 45) but, most important, it also leads to a new insight into color mixture after an unavoidable surprise is recognized.

The surprise is that the gradual "increase in depth" promised above does not appear—as most people will expect—in a succession of equal steps. Nor, when mixing pigments, does an equal gradation appear when an equal quantity of the same color is continually added.

In this case a continued application of such layers would unavoidably lead to such a degree of decrease that the initial increase would disappear in a final, unsurpassable, and unchanging saturation.

Analyzing Chevreul's method of applying one layer on top of another, one recognizes not only an additive mixture with regard to color, but also a subtractive mixture with regard to light. More precisely, this demonstrates an arithmetical progression in both directions—and both are physical progressions only.

In the diagrams on page 56, this physical fact is presented by a row of rising steps of equal height and width, the movement of which follows a straight line.

As said before, and clearly shown in Klee's water colors, the rate of increase gradually decreases. Therefore, the rise of the steps will be less and less high. Consequently, the physically straight line of direction becomes psychologically a curve, ending in a horizontal line representing saturation, which ends both increase and decrease.

This leads to the question: what is necessary to produce a visually even progression in mixture?

The answer was found by Weber (Wilhelm Eduard, 1804–91) and Fechner (Gustav Theodor, 1801–87). It is formulated in the so-called Weber-Fechner Law: The visual perception of an arithmetical progression depends upon a physical geometric progression.

Explained in diagrams shown on the next page, this means: If the first 2 steps measure 1 and 2 units in rise, then step 3 is not only 1 unit more (that is, 3 in an arithmetical proportion), but is twice as much (that is, 4 in a geometric proportion). The successive steps then measure 8, 16, 32, 64 units. Such increases describe an upward curve ending in a straight vertical line, meaning, again, saturation.

However, the reading of such geometric increase will describe a straight line in our mind. We think and "feel" that we read steps of equal height.

To demonstrate this surprising discrepancy between physical fact and psychic effect, and, more important, to become convinced of it through one's own experience, the following exercise is recommended:

On a white paper, layers of very light transparent coats of a very thin color are placed on top of each other; first, as M. Chevreul suggests, in an arithmetical progression (1, 2, 3, 4, 5, etc. layers); then, in a second row, in a geometric progression (1, 2, 4, 8, 16, etc. layers), on the same paper. In both rows, contiguous steps of equal width are required.

1	+	\vdash	+
 	+		

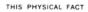

REDUCES TO

THIS PSYCHOLOGICAL EFFECT

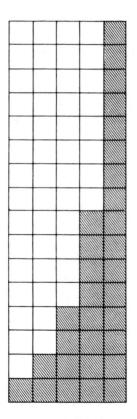

_			
	1		
			· · · ·
			VIIIIIII
			VIIIIIIV
			011111110

THIS PHYSICAL FACT

PRODUCES THIS PSYCHOLOGICAL EFFECT

For accurate comparison of the 2 rows—of arithmetical and geometric increases precision is necessary. For this reason, water color should be avoided, because it rarely provides even coats and always ends not only in heavy but in unevenly heavy contours. Most advisable is the use of film-like acetate sheets of the thinnest tints available, with adhesive backs which provide the advantages of easy montage and invisible paste. There are several makes, such as "Zip-a-tone," "Artype," and "Cello-tak."

In case these are not available, very thin translucent paper (waxed sandwich paper) might demonstrate—in transparence—the 2 different effects, when observed against light.

For another demonstration in turbid means—in reflected light layers of thinnest whites on black paper will provide proof in an opposite direction the very different effects of arithmetical and geometric increase or decrease.

These studies also teach that the "decreasing increase" can be seen in the boundaries separating the steps: In an arithmetical order of contiguous mixtures, the boundaries gradually become softer, whereas in a geometric order the boundaries remain equally distinct.

Such studies, of course, are only theoretically true. Because of slight material imprecisions, the studies show occasional aberrations from the rule.

Though the Weber-Fechner Law enables "equal stepping up" (in light and in dark, within specific hucs), it is deflected by the relativity of color.

In steps which are not much wider than they are deep, these steps visually do not remain horizontal or on an even level, as in the diagram on page 58, left.

In steps which are broader, a "fluting" effect occurs, reminiscent of the channeling of Doric columns, as in the diagram on page 58, right.

A convincing outdoor demonstration of the Weber-Fechner Law is presented in swimming pools painted, for example, blue. Because of reflection, the water appears thinly tinted blue. Visually following the steps downward, one easily recognizes an increase of blueness. Since the steps are equally deep, equal amounts of blueness are added. This arithmetical physical proportion is again perceived in a decreasing geometric proportion. When the edges of the steps are compared in a downward direction they appear gradually softer. There is a double reason for this effect: First, as the increase of blueness simultaneously reduces light, the defining edges of the steps appear less clear. Second, as the increase in blueness also decreases, the contrast between neighboring blues is reduced. Consequently, the separation of the edges of the steps becomes less distinct. Both reasons follow the Weber-Fechner Law and are unrelated to any law of light refraction. Although light refraction also causes illusion in visual perception, it presents an entirely different principle because it is concerned with an optical effect. The Weber-Fechner Law explains a perceptual phenomenon.

It is surprising and unfortunate that the Weber-Fechner Law is almost unknown among colorists. Its importance is more recognized in physics—in astronomy, electricity, and acoustics. It also proves to be important in psychology—in the perception of sound, weight, temperature—as well as in the perception of light and color. (See plate xx-1.)

The presentation below of the important Weber-Fechner discovery was simplified visually and verbally for an easier understanding, but it should be emphasized that all Weber-Fechner calculations are done in logarithmic progressions which theoretically do not reach saturation points.

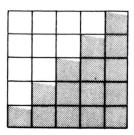

ACTUALLY PERCEIVED

XXI From color temperature to humidity in color

Earlier, when explaining light intensity as lightness and color intensity as brightness, we found that agreement is easier in the first case, and difficult in the second.

This is because, in defining such qualities, we deal on the one side with physical facts and on the other with perceptual reactions which permit either a factual measure or an interpretation of illusions. As a result, there are in the latter case various views and opinions, and different, if not contradictory, readings.

Any measuring of light-dark qualities is not unrelated to a scaling of light-heavy relationships. Light-dark and light-heavy lead easily to soft-hard comparisons; or, quick-slow and early-late connect with young-old, and with warm-cool, as well as with wet-dry.

Such and other chain connections have led even to such opposites as here and there, indicating spatial differentiation.

The 2 most comprehensive of the above polarities in color are first, light-dark and light-heavy, and second, the temperature contrast warm-cool.

In defining the placement of such contrasts within color circles, we will see, besides their uneven distribution and their so-called neutrals separating them, their slight overlappings of each other when we compare one circle with the other. (See diagrams, next page.)

As to warm and cool, it is accepted in Western tradition that normally blue appears cool and that the adjacent group, yellow-orange-red, looks warm. As any temperature can be read higher or lower in comparison with other temperatures, these qualifications are only relative. Therefore, there are also warm blues and cool reds possible within their own hues.

But when these temperature indicators, red and blue, are combined with color neutrals, as whites, blacks, and greys, and with their mixtures, particularly in mixtures with the temperature neutrals green and violet, then personal interpretations of temperatures may easily become disparate. Therefore, it will be comprehensible that such theories of interpretation may lead to and end in personal beliefs. So it is not surprising that the warm-cool principle in color which successfully dominated the Munich school of painting around the turn of the century resulted finally in fruitless controversies.

It was successful in gaining followers by offering a theory for defining spatial relationship of colors, through their higher and lower illusional temperature. As this warm-cool relationship was closely connected with the light-dark contrast, the hardest but apparently lasting conversion then was that light was cold and shadows warm, at least outdoors. It split up in factions of different beliefs about the function of cool and warm with regard to spatial directions in painting, whether the <u>here contra there was decisive</u>, or the <u>above contra below</u>, or the <u>in contra out</u>. A clear example of these opposites is the contrast between Boucher's receding deepening with vermilion red, and Rubens' advancing heightening with white.

All this may be a reason why the warm-cool contrast is not in fashion today, although a new theory declares warm near and cool far, because the former is of longer and the latter of shorter wave length, and they are, therefore, optically registered in different ways. But optical and perceptual registration are not necessarily parallel. (See plate XXI-1.)

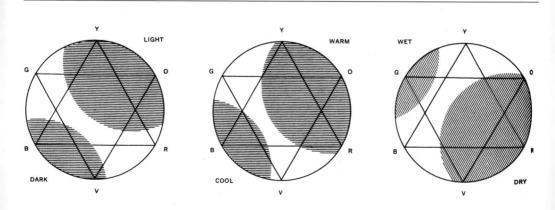

XXII Vibrating boundaries enforced contours

As a deception, this effect is related to our earlier experience in which 2 colors appeared as 3 or 4 colors.

However, the additional illusionary colors often are hard to define as to their hue.

They often appear as shadow on one side of the boundary and as light reflected on the other side.

Or sometimes this vibration presents just a duplication or triplication of the boundary line.

The conditions for these varying effects occur between colors which are contrasting in their hues but also close or similar in light intensity.

Though this effect refers to the after-image, its physio-psychological function apparently seems not to have been clarified.

Often, under the same conditions, it is perceived by some people and not by others.

It is visible and not visible with or without glasses; or, similarly, with interchanging of near and far focus.

This initially exciting effect also feels aggressive and often even uncomfortable to our eyes. One finds it rarely used except for a screaming effect in advertising, and as a result it is unpleasant, disliked, and avoided. (See plates XXII-1 and XXII-2.)

XXIII Equal light intensity vanishing boundaries

Though rarely perceived, it is a fact that articulate boundaries between colors can be made nearly unrecognizable, or made practically invisible—through the choice of color alone.

This very surprising and most exciting of all color phenomena depends, like all other effects, on specific conditions.

The effect is the opposite of the aforementioned vibrating boundaries, and it is not possible between very contrasting hues. It is confined to adjacent, neighboring colors and depends most decisively on equal "light intensity." Only real equality in lightness or an equivalent real equality in darkness produces the effect here aimed at and searched for.

Now, since the term "equal value" has unfortunately been misused too often for colors lacking just this quality, incompetent judgment has distorted this term to a falsified measure. In this way, "equal values" are more spoken about than realized—than actually seen.

Thus, we can safely state that very few people—including many colorists and painters—have ever seen 2 adjacent colors of true equal light value—that is, of exact equality in light, of the same level of light, or, in a sense, the same altitude of light.

This will indicate that equal light intensity presents, besides a most challenging exercise, a most difficult task demanding most of all—patience.

Because several of our color classes were not able to present even 1 convincing color couple of equal light intensity, this makes it an exercise for teachers willing to demonstrate that in all teaching the personal example is the strongest incentive. Earlier, right after the test "Which is the lighter and / or darker?" we had the opportunity to prepare for this difficult exercise, which usually is the last exercise of our course.

When we were collecting pairs of colors hard to distinguish as lighter or darker we were often tempted to consider some of them to be of "equal value."

At that time we learned that in cases difficult to decide upon, which we named "near-equal light intensities," or "almost-equals," the after-image test can be a helpful measure. (See diagram, page 13.)

Though sometimes it may appear hopeless to find equal light intensities in paint and painting, in color papers, or in our surroundings, we have found that nature occasionally provides an opportunity to see them on cumulus clouds against blue sky.

When these clouds, often lined up in horizontal groups, appear gleaming white in their upper part in full sunlight, separated from and rising against a distant deep blue, then underneath they show grey tones as shaded white. These shades merge, or even hinge, with the same but here very close blue. Why very close? This grey is of the same light intensity as the neighboring blue below. Thus, the boundaries between grey and blue vanish, and we do not see where clouds end and where sky begins. With such clouds, this is best observed with the sun at our backs.

In order to produce this provocative color effect—but also the most delicate one—all disturbing effects of paper (such as different surfaces) and of montage (visible edges or paste marks) must be carefully avoided. (See plate xx111-2.)

Therefore, the 2 papers of equal light intensity must be mounted as inlay (known as "intarsia").

In this process the papers are placed within each other, instead of on top of each other. Thus the thickness of the paper does not show, and, more important, its very disturbing shadows are eliminated—provided the papers are of equal thickness.

For precision fitting, so that the joints will not show, the papers to be inlaid are formed simultaneously in a single cutting.

The finer the knife (best, the thinnest razor blade), the thinner the paper, and the harder the ground to cut on (preferably glass), the better the fitting will be and the less the joints will show. It is also essential that no glue seep in to mark the joints.

As the selection of the papers here demands patience, so their presentation demands skill and cleanliness.

XXIV Color theories—color systems

Originally, we began our color course with a presentation of various color systems, of color theories.

With the discovery that color is the most relative medium in art, and that its greatest excitement lies beyond rules and canons, a more sensitive discrimination was needed.

The more a creative use of color developed, the less desirable became a merely trustful and obedient application.

A sensitive eye for color became our first concern.

As a result, we came to present color systems not at the beginning but at the end of our course.

We learned that their often beautiful order is more recognized and appreciated when eyes and minds are — after productive exercises better prepared and more receptive. In a laboratory course as described, it is not the ambition to provide a comprehensive knowledge of many theories. We can introduce only briefly the most important systems, which are systematic groupings of the colors of the visible sun spectrum, presented in 2-dimensional or 3-dimensional order. However, we encourage extended interest in private study of theories.

In presenting systems showing organized color relationship, we usually start with the rarely published equilateral triangle subdivided into 9 equilateral triangles, shown on page 66. (See also plate XXIV-1.)

We then refer to Schopenhauer's experiment on the relation and balance of light with quantity within the color wheel, as explained on page 43.

Of the contemporary systems, we present and analyze briefly the order of the Munsell Color Tree, as well as the Ostwald Color System, and show an offspring of the latter, the Faber Birren Color System.

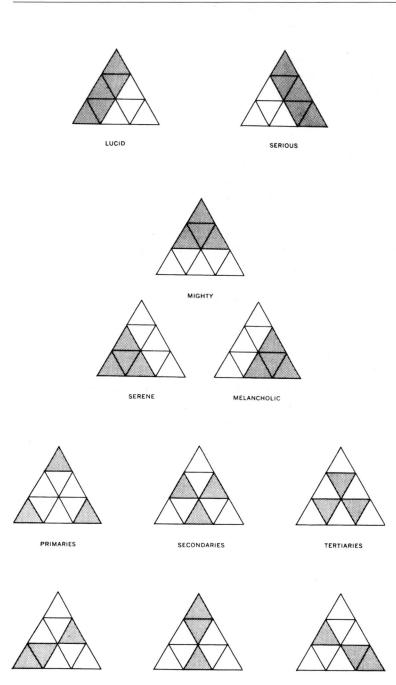

COMPLEMENTARIES WITH THEIR MIXTURES WHICH ARE DOMINATED BY THEIR PRIMARIES

Besides the difference in measurements within these systems, we point out their practical value for industrial uses.

We also show the limitations of the systems, particularly in connection with painting. Only the Munsell System presents a calculation of color quantity with regard to area extension, without counting an additional effect through recurrence.

We emphasize that color harmonies, usually the special interest or aim of color systems, are not the only desirable relationship. As with tones in music, so with color—dissonance is as desirable as its opposite, consonance.

After such brief introduction to established color systems we introduce a more recent, most important development, the spectrophotometer, for automatic color analysis.

Since no purpose is served by going into further details of color systems, it seems worth while to distinguish 3 basically different approaches to color based upon the different interests of the physicist, the psychologist, and the colorist. To indicate only a single difference: whereas the primary colors for the colorist (painters, designers) are, as we know, yellow-red-blue, the physicist has 3 other primaries (not including yellow), and the psychologist counts 4 primaries (the fourth being green), plus 2 neutrals, white and black.

XXV On teaching color some color terms

In the previous chapters we have presented a studio course, or, if you prefer, a laboratory or workshop course which opposes an administrative attitude of "theory and practice." Naturally, practice is not preceded but followed by theory. Such study promotes a more lasting teaching and learning through experience. Its aim is development of creativeness realized in discovery and invention—the criteria of creativity, or flexibility, being imagination and fantasy. Altogether it promotes "thinking in situations," a new educational concept unfortunately little known and less cultivated, so far.

We have described, up to now, the basic color problems to be solved, and have presented them in a logical sequence in which each problem prepares for following ones.

The color plates selected for reproduction in this edition are strictly studies, that is, experimental tryouts. They aim at 1 distinct effect only, which, at the time, was given as an exercise, obligatory for all members of the class. These exercises are not meant to illustrate, or to decorate or beautify something, but aim at the development of the ability to produce the desired color effects. This reiterates our disbelief in self-expression, either as a way of study or as its aim, in schools.

After too much non-teaching, non-learning, and a consequent non-seeing, —in too many art "activities"—it is time to advocate again a basic step-by-step learning which promotes recognition of insight coming from experience, and evaluation resulting from comparison. This, in sum, means recognition of development and improvement, that is, of growth, growth of ability. This growth is not only a most exciting experience; it is inspiring and thus the strongest incentive for intensified action, for continued investigation (search instead of re-search), for learning through conscious practice. Gestalt psychology has proved that 3-dimensionality is perceived earlier and more easily than 2-dimensionality. This explains why children do not begin—as most art teachers still wish—with painting and drawing, which are lateral abstractions on a 2-dimensional plane, but begin all by themselves with building, constructing in space, on a ground and upward, in 3 dimensions.

We believe that art education is an essential part of general education, including so-called higher learning. We promote, therefore, after a natural and easy laissez-faire as an initial challenge, an early shift from aimless play to directed study and work, which offers, with a basic training, a continuous excitement of growth.

To say this in psychological-educational terms, it means a shift from a recognition of the first but primitive drive for being occupied, entertained—<u>Beschäftigungstrieb</u> to a more advanced drive, or better, need, for being productive, creative—<u>Gestaltungstrieb</u>.

The results of our trial-and-error experimentation, mostly done after class, are exhibited at the beginning of the next class. (These studies we call the "admission tickets" to the class.)

They are then compared and evaluated by the entire class, students and teacher. First, every class member makes his selection and compares his preferences with his own contributions. Then, we — that is, the teacher or a student or students—select the best examples of "psychological engineering." This qualification we confer on a convincing presentation because it eliminates misleading reading of the study's purpose and its desired effect.

The normal procedure in presenting a new problem often is to show a sample exercise and to point to its specific effect. The class is then asked to produce equal effects with similar and other colors—without first being told how to do it.

After a while, a collection of the first trials—wrong as well as "on the way" or right—will give an opportunity to lead, to direct, to point at (or to indicate only by comparison forth and back) new ways of promising investigation. It comes as a pleasant surprise in a step-by-step learning that the further the course proceeds, the more each succeeding problem is accidentally if not actually presented among the studies shown at the beginning of a class. The teacher may prefer to present the new problem with this "step ahead" (thus evading his own prepared presentation), as a new direction emanating from the class. This "step ahead" will prove a most contagious stimulus to the class.

As basic rules of any language must be practiced continuously, and therefore are never fixed, so exercises toward distinct color effects never are done or over. New and different cases will be discovered time and again, and should be presented to the class again and again. In this way the study will be a mutual give and take. It will also show that all thorough study is basic, and that all education is self-education. This indicates that we expect from every student several solutions to each problem.

In the end, teaching is a matter not of method but of heart. Therefore, the most decisive factor is the teacher's personality. His enthusiastic concern with the student's growth counts more than how much he knows. It is well known that "the teacher is always right," but rarely does this fact elicit respect or sympathy; even less often does it prove competence and authority.

But the teacher actually is right and always will gain confidence when he admits that he does not know, that he cannot decide, and, as it often is with color, that he is unable to make a choice or to give advice.

Besides, good teaching is more a giving of right questions than a giving of right answers.

A few color terms which need additional explanation

Relativity:

The length of any object is relative to the length of longer or shorter objects. Thus, any in-between length, seen in 2 different relationships, presents 2 different values. Therefore, changing measure results in changing evaluations. In a similar way, as we learned before, 1 temperature can feel as 2. Also, weight may be registered in different ways. If, of 3 hands, the first holds only a small sheet of paper, the second a pile of sheets or a book, and the third a pile of books, then physically each of the 3 hands is exposed to weight. The first will feel nothing or only a soft touch, the second clearly some pressure downward, and the third may even feel pain.

Relativity is caused by a variance of measure, by lack or avoidance of standard rules, or by changing viewpoints. As a result, 1 phenomenon has varying views, readings, and different meanings.

This instability of value is extremely characteristic of color. Resulting from the after-image, a light grey, for instance, may look dark at one time and almost white at another, and at various times like a shade or a tint of any color, as green may look reddish.

The purpose of most of our color studies is to prove that color is the most relative medium in art, that we almost never perceive what color is physically.

The mutual influencing of colors we call—interaction. Seen from the opposite viewpoint, it is—interdependence.

Though we were taught, only a few years ago, that there is no connection whatever between visual and auditory perception, we know now that a color changes visually when a changing tone is heard simultaneously. This, of course, makes the relativity of color still more obvious, just as tongue and eye perceptions interdepend when colors of food and of its containers increase or diminish our appetite.

Factual—Actual:

In dealing with color relativity or color illusion, it is practical to distinguish factual facts from actual facts.

The data on wave length—the result of optical analysis of light spectra we acknowledge as fact.

This is a factual fact.

It means something remaining what it is, something probably not undergoing changes.

But when we see opaque color as transparent or perceive opacity as translucence, then the optical reception in our eye has changed in our mind to something different. The same is true when we see 3 colors as 4 or as 2, or 4 colors as 3, when we see flat, even colors as intersecting colors and their fluting effect, or when we see distinct 1-contour boundaries doubled or vibrating or just vanishing.

These effects we call actual facts.

This kind of fact seems parallel to the common saying, "what actually happened," that is, what happened in time, what went on, what moved, what developed.

But "actual size" usually means something fixed, something remaining permanent, standing still. Therefore, "factual size" would be more truthful because "actual" is related to "action." It is something not fixed, but changing with time.

"Action" is the noun for the verb "to act." Acting in visual presentation is to change by giving up, by losing identity. When we act, we change appearance and behavior, we act as someone else.

For further clarification, therefore, actors who present only themselves remain always the same. They may appear interesting, but they do not act. In our terms they remain factual. However, when an actor is able to appear as Henry VIII, so that we overlook or forget who he factually is, and when he also can be expected to play Henry ix or Henry x, then he is a real actor, able to give up his own identity and present someone else's appearance and personality.

Color acts in a similar way. Because of the after-image (the simultaneous contrast), colors influence and change each other forth and back. They continuously interact—in our perception.

Value:

The word as such, when unspecified, permits application in innumerable directions. By itself, it does not reveal on what level, in what direction or field evaluation is meant.

In color, it is a distinct measure only in connection with the Munsell System. There, Munsell defines value as the lightness of a color. In connection with other systems it has no outspoken meaning. The French word <u>valeur</u> has a broader meaning. Unfortunately, the careless use of "value," particularly with regard to equal lightness—as well as false examples reproduced in books—has destroyed it as a means of measure. Therefore we use "light intensity" instead as a self-explanatory term. (See Chapters v, page 12, and XXIII, page 62.)

Variants versus variety

The word "variety," although recently a favored design term, has become discredited because of increased abuse. It has become a pretentious recommendation for designs of questionable merit. It is applied to protect hurried changes, to excuse poor alterations, or to defend any accidental and meaningless whim. It even appears as a weapon to prevent rejection, to force credits. Thus the excuse "for variety's sake" remains a warning signal.

To replace this negative criterion, we are in favor of a related word of better reputation, the design term "variant." As variety usually concerns changes of details, variant means a more thorough re-doing of a whole or of a part within a given scheme. Although variant may remind us slightly of imitative plagiarism, normally it results from a thorough study. Because of a more comprehensive comparison forth and back, it usually aims at a new presentation. On the whole, variants demonstrate, besides a sincere attitude, a healthy belief that there is no final solution in form; thus form demands unending performance and invites constant reconsideration—visually as well as verbally.

XXVI In lieu of a bibliography my first collaborators

This book presents results of search, not of what is academically called research.

As it is not a compilation from books, it does not end with a list of books—either books read, or books not read.

Instead, this book ends with an acknowledgment of my students who are the authors of the sample studies, and whom I therefore consider my indirect but first collaborators.

In addition to the dedication of this book, I should like to state that my students in color have taught me more color than have books about color.

Many students of this color course (which has been developed in the United States) not only have found solutions of their own to known problems, but also have visualized and discovered new problems, new solutions, and new presentations. Although rarely shown, and therefore barely known so far, their contributions deserve publication in the interest of a new intensified training of eyes and minds—in both art education and general education.

Those contributions come from 2 sides, from a majority of normally gifted students, as well as from the minority of more gifted students. And particularly this majority has taught me how to proceed, how to open eyes and minds; even more important, it has taught me what not to do.

We should have liked to name here the authors of all the sample studies reproduced in the first edition. Unfortunately, many names are lacking, uncertain, or lost. The known names are listed alphabetically in the original edition, followed by the numbers of the folders containing their studies.

Plates and commentary

A color has many faces—the relativity of color CHAPTER IV

IV-1

A color has many faces, and 1 color can be made to appear as 2 different colors. In the original design for the study IV-1, horizontal dark blue and yellow stripes were on a flap which could be lifted to show that a vertical stripe of ochre is the same color at the top as at the bottom.

Here it is almost unbelievable that the upper small and the lower small squares are part of the same paper strip and therefore are the same color.

And no normal human eye is able to see both squares-alike.

Note: Plate numbers correspond to Folder numbers in the original edition.

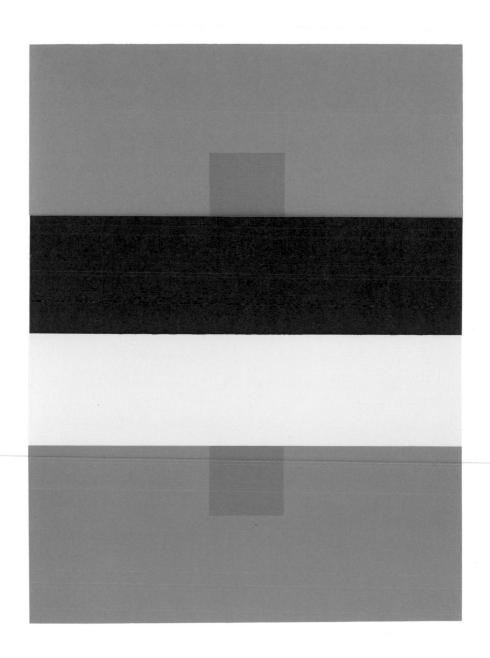

Why is the green presented as a grill? Or, what is the perceptual reason for it?

78

IV-3

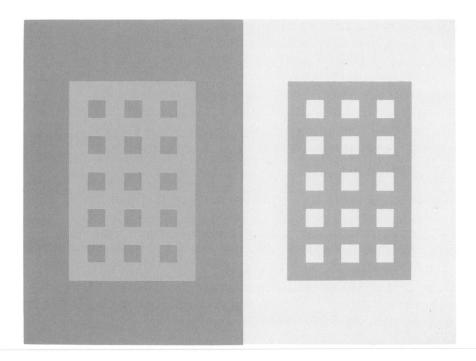

Gradation studies CHAPTER V

V-1

The gradation in plate v-1 is a collage of small snippets of greys carefully collected from magazine illustrations, which should come from the same publications to ensure the same hue of the black.

They are arranged downward in the softest possible transition from deep black to clear white, and then mounted as 4 equal-sized rectangles on a cardboard sheet of a correct middle grey so that they appear as in a window frame with a central cross, of which all parts are the same width.

This combination of decreasing blacks into clear whites within an unchanging framework results in the following interaction: the 3 verticals of the frame appear increasingly lighter toward the top, and similarly darker toward the base.

Of the 3 horizontals within that frame the upper appears lighter, and the lowest one darker. And the middle horizontal almost vanishes from merging with its neighboring middle-grey snippets.

Although such study depends very much on precision and patience, similar studies should be encouraged. It should be mentioned that samples of a real middle grey are hardest to find.

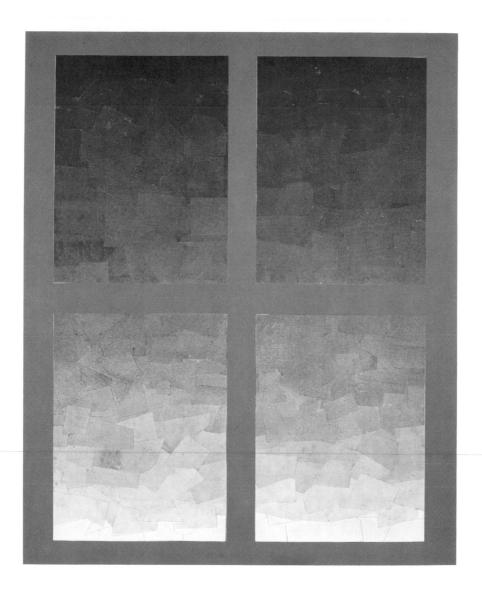

v-3 For the study of color intensity or brightness, we selected from 8 tints, shades, or tones the 1 most typical for each hue, and presented it as such through an emphasis on placement. For a "fair" comparison, all samples appear in the same amount and the same shape. As stated before, personal preferences and prejudices will result in diverging votes, or selections.

Reversed grounds CHAPTER VI

VI-3

1 color looks like 2—or: 3 colors appear as 2. In plate VI-3 when you hold the yellow ground at the left, the X-form on it appears violetish and the X-form on the violet ground looks yellowish.

To show that both X's are the same color, see where they meet in the middle at the top.

The question that this study presents: What color is able to play such complementary roles in one show?

VI-4 3 colors appear as 2.

On brown and violet grounds, the center squares look like the grounds exchanged, violet and brown. But they are of the same color, precisely alike, and at the same time refer to the neighboring grounds. The true color of the 2 central squares therefore becomes unrecognizable, as it loses its identity.

Subtraction of color CHAPTER VII

VII-4 Hold plate VII-4 with the deep green ground on the left, and the light grey ground on the right.

Below them are 2 contiguous horizontal stripes, the upper one a brownish-green on top of a thin ochreous yellow.

The small rectangles in the centers of the large rectangles seem to be alike.

For the best simultaneous comparison do not look from one center to the other but focus firmly on a point in the middle between them, which will be within the boundary of the grounds.

This is a courageous example of making 2 very different colors look alike. It proves that its author understood the meaning of "subtraction of color." In other words, how to get rid of too much dark or light in a color, or too much hue, as the green or yellow.

VII-5 We see 1 pair of larger upright rectangles and 2 pairs of smaller horizontal rectangles, each pair connected along a vertical axis. The 2 upper pairs carry narrow stripes, on the larger as diagonals, and on the smaller connected in a central horizontal axis.

As to color, the deep red and yellowish off-white grounds at top are reversed in the second pair. The quite different lower pair contains a clear contrast, Naples yellow and ochre.

When comparing the 2 diagonals simultaneously, that is, not in sequence but focusing on the middle between them, they will appear very similar or even alike. But they are precisely the same as the horizontal stripes beneath them, and therefore factually as different as the colors at the bottom, which are ochre and Naples yellow.

Reading the study in the opposite direction—upward—the quite different Naples yellow and ochre, when seen reversed on the contrasting grounds of the middle pair, appear even more different. But when shown in the same order on the reversed colors of the upper grounds, they change from a distinct contrast to a pair of similar colors. Naples yellow and ochre are changed to look alike.

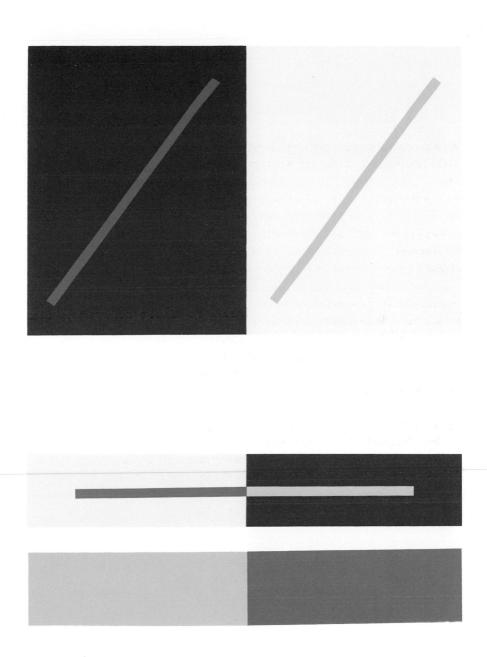

VII-7 This study shows a very courageous solution to the problem because it makes a very light grey and a dark, almost black-grey appear alike.

Of the 3 small rectangles at right, the 2 lighter ones (above each other) are exactly alike, and look exactly alike since they are seen on the same ground, white.

The third small and connected rectangle—because of its darkness appears in color similar or equal to the large dark ground at the left. Thus, it seems unbelievable that the small dark one is precisely repeated in the center of the dark ground where it looks much lighter—unbelievably lighter.

Now, having next to each other dark on darker and light on lighter the left and right center as horizontal neighbors in parallel optical conditions (equal placement, shape, and quantity relationship)—we are able to compare them. If this is done properly, which means simultaneously (not alternatingly, as explained before), we will perceive that the white-grey and the black-grey, seen first as connected contrasts, appear alike. Q. E. D., what was to be proved.

For a visual proof, make a flap by tracing the 2 dark-grey rectangles on a sheet of paper from your school notebook (usually slightly translucent), cut them out, somewhat smaller, and compare what you see through these openings.

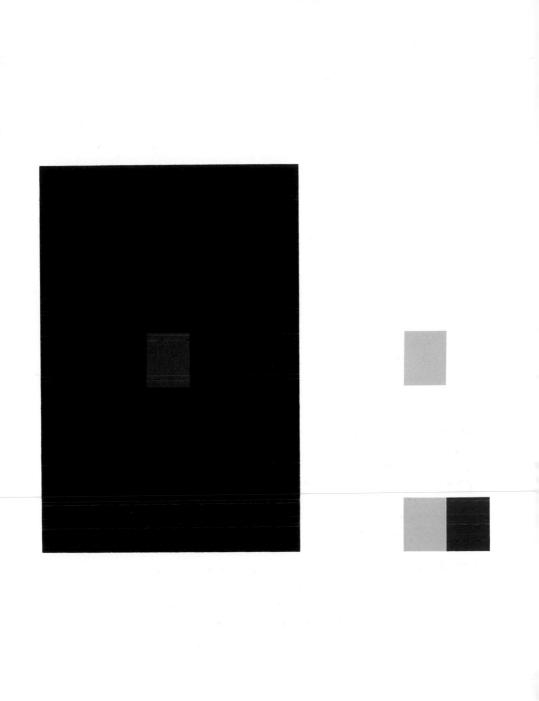

After-image CHAPTER VIII

VIII-2

For a clear understanding of interaction of color caused by interdependence of color we should experience what "after-image" means. Before going on to study plate v111-2 complete the exercise described on page 22.

Now look at plate VIII-2 horizontally. On the left are yellow circles of equal diameter which touch each other and fill out a white square. There is a black dot in its center. On the right is an empty white square, also with a centered black dot. Each is on a black ground. After staring for half a minute at the left square, shift the focus suddenly to the right square.

Here one experiences a very different after-image. Instead of seeing the complement of the yellow circles (blue), diamond shapes are seen—the leftover shapes of the circles—in yellow. This illusion is a double and thus reversed after-image, sometimes called contrast reversal.

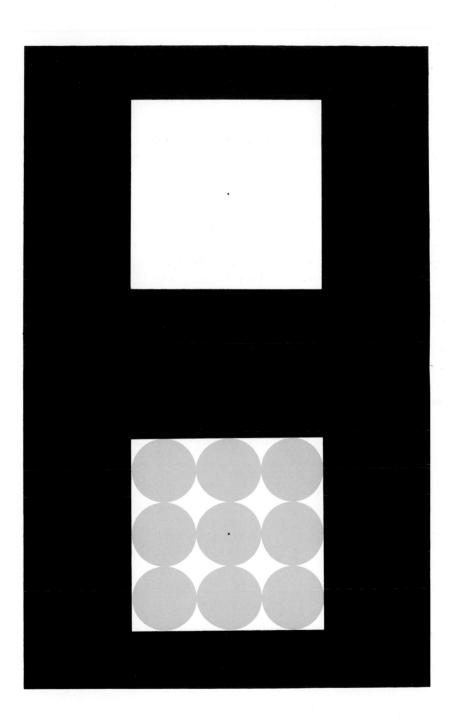

Color mixture in paper CHAPTER IX

IX-1 In painting it is easy to mix pigments by pouring them together and stirring them, which achieves an in-between color as a mixture. Since this is not possible with paper, we must imagine a possible "in-between color." In plate IX-1 we superimpose part of a brown rectangle on a rosy-red rectangle. First we pass our eyes from left to right several times across the overlapping area, in which the mixture should appear.

After several passages back and forth we see that the red appears to come through the brown at the left, and the brown seems to come through the red at the right border of the overlap. This is proof that we have a true mixture.

It is easy to see that the right edge of the brown rectangle has a heavier boundary than the left edge of the red. Therefore this mixture contains more brown than red. Thus, the brown is on top; in other words, the brown is dominant in the mixture.

Now try to find a mixture in which the red is on top and therefore dominant.

Read Chapter XI and find some color mixture in paper that produces various space illusions.

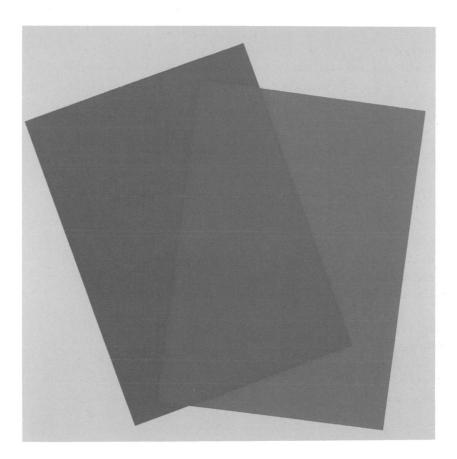

Additive and subtractive mixture CHAPTER X

X-1

Hold plate x-1 with the dark background on the left. Obviously both studies are based on the same underlying design of 3 overlapping rectangles, providing a common subdivision of area.

The 3 rectangles are of equal shape and size, and hinged in their combined left corners. They are, furthermore, related as tints of the same color, namely a grey-violet.

With regard to light, the 2 groups of rectangles move in opposite directions. At left, from a dark ground to a light center, at right from a light ground to a dark center.

On both sides, each of the 3 rectangles overlaps the 2 others only once. By looking transparent (in fact, they are opaque) they produce in our perception illusions of mixture, in 3 steps of either light or shade—a gradual increase in light at the left but a decrease in light at the right.

With their contrasting results of gaining and of losing light, these studies explain a basic difference in mixture, that is, mixture in direct color—which is light—and its opposite, mixture in reflected color—produced by pigment.

The first, the product of a mixture by a physicist, by combining light (direct color) results in addition of light. Whereas the second, a combining of pigments (indirect, reflected color) and done by the colorist, results in subtraction of light.

Now, since both studies are done in pigments (inks), they "present," in fact, reflected light only; they also "represent," in illusion only, at right, subtractive mixture, the area of the painter, and at left, additive mixture, the realm of the physicist.

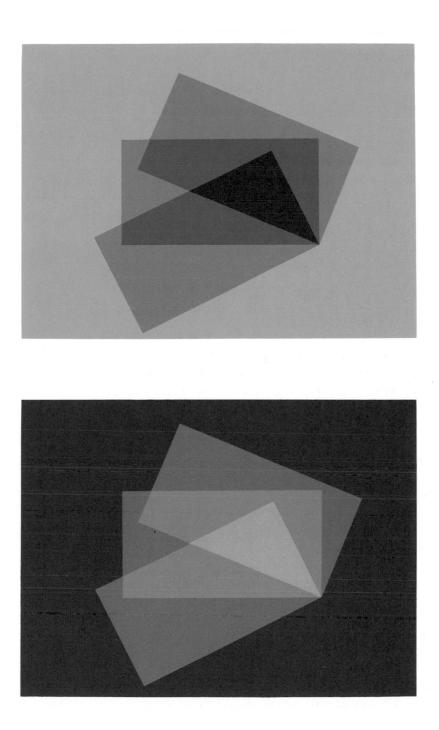

Transparence and space-illusion CHAPTER XI

XI-1 This deserves recognition as an unusually precise study of a mixture of 2 colors in a gradation of 9 equidistant steps of red—equidistant by their proper increase of yellow content. It presents itself most actively when seen with the little dot in the upper left corner. Then the gradual upward increase in light reads more decisively than the equally precise increase in red in the opposite direction.

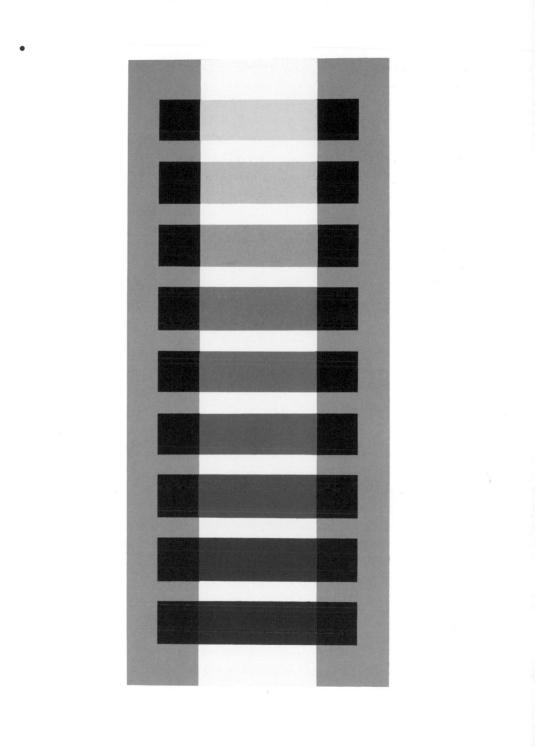

XI-3

It will be immediately clear that of the 3 horizontal black bars which overlap and mix with the broad vertical white (in 3 different greys), the lower bar appears on top of the white, whereas the upper bar looks overlapped by the white and therefore behind or underneath it.

Or, when following the white upward, it starts behind the black, but ends up on top of it.

Such readings are caused by the dominating contents of the mixtures, as well as by their boundaries.

The lower mixture obviously contains more black and the upper mixture, just as clearly, more white.

Since the harder and therefore leading boundaries are products of the dominating stronger contents, they define the movement of the mixture.

As a result, the harder, louder boundaries of the lower bar are horizontal, which means separation upward and downward, and moving sideward. The dominating boundaries of the upper, lighter mixture are vertical connections, sideward separations, and moving upward.

Indirectly, this also explains the mixture in the middle. The black and white contents are equal, or nearly equal, and so are the mixture boundaries; all of which indicates that neither black nor white is on top, but that both penetrate each other on a 2-dimensional level—without any spatial separation—and thus show a "middle mixture."

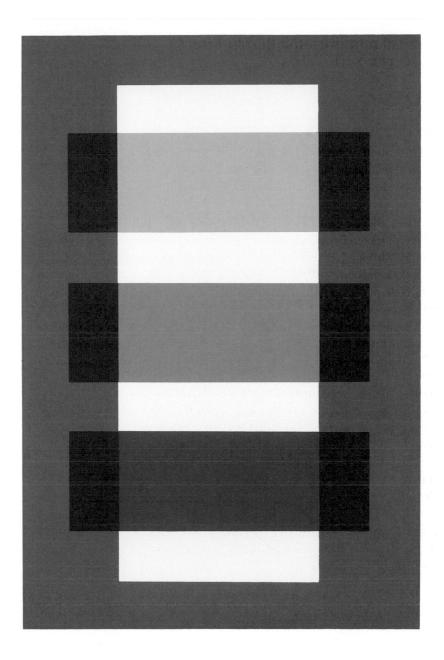

Optical mixture—the Bezold Effect CHAPTER XIII

XIII-1

The French Impressionists (after 1870) aimed at an optical mixture effect. Instead of mixing their colors on their palettes, they applied them in small dabs on the canvas so that the colors were mixed, at a distance, in our eyes.

A similar effect is named after Wilhelm von Bezold (1837–1907), a meteorologist in Berlin, who discovered that certain strong colors, when evenly distributed, changed entirely the effect of his rug designs, which were his avocation.*

One of my color students, following Bezold's example, showed in plate XIII-1 light red bricks laid up with very white mortar, and then showed the same bricks laid up with pure black mortar. The red with the white looks much lighter than the red with the black, particularly at a distance.

*The Theory of Color and Its Relation to Art and Art Industry, trans., Boston, Prang, 1876.

XIII-2 The change of 1 color alters both light and weight of the original, and, one can say, its speed and age as well.

Another reading: besides the Bezold Effect, its opposite appears here—an after-image effect—when the dark red flanking the black is compared with the same red accompanying the white. Define this change.

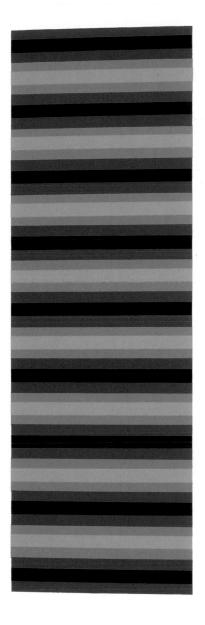

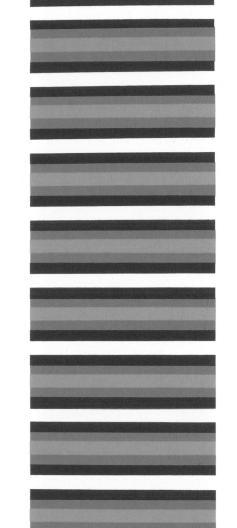

XIII-3 This commercial decorative design for a printed textile (of questionable merit) is the point of departure for proving the Bezold Effect. It shows the original condition in the upper part.

Substituting white for the black, it lights up all other colors, which is the aim of the Bezold Effect and of this study.

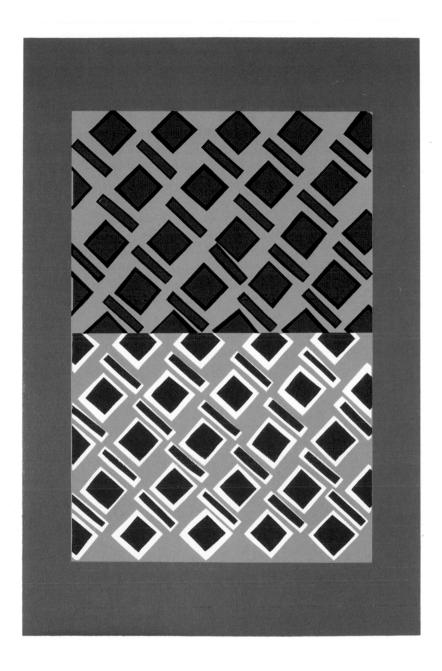

Color intervals and transformation CHAPTER XIV

XIV-1 A "transformation" of 4 reds to 4 blues of a slightly lower key seems comparable to a transformation of a tetrachord in music from 1 instrument to another. Therefore we are also in color concerned with "intervals." But such rearrangement is far more complicated with colors than with musical notes.

Upstairs in plate XIV-1 we have 4 red squares at the left, making one square, and 4 blue squares at the right, also making a square. Each has its darkest squares on the left. In the top row of each the strongest contrast exists between the left and right squares, and they are separated by the hardest boundaries.

To demonstrate whether they provide the same "intervals," downstairs we transfer the blue square arrangement to the center of the reds, and vice versa. After this transformation, if the intervals are correct, the hardest boundary in the top pairs of squares is repeated in the upper halves of the vertical axis, and the lower pairs show the evenly softer boundaries.

In order to train your eyes, compare the corresponding boundaries upstairs and downstairs, from left to right. Then you will see that in all four cases the left vertical halves are heavier and that the right vertical halves are foggy. Read Chapter XIV and look at the 6 drawings that illustrate it.

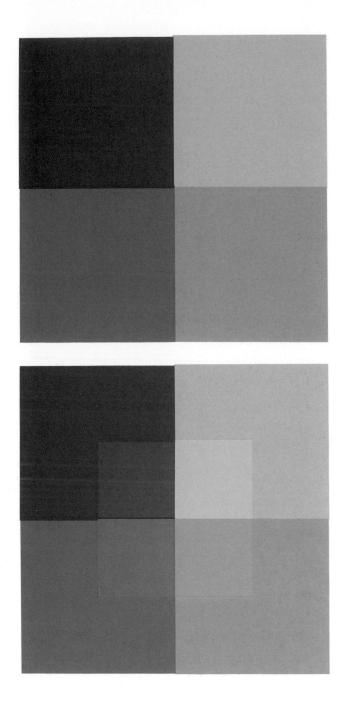

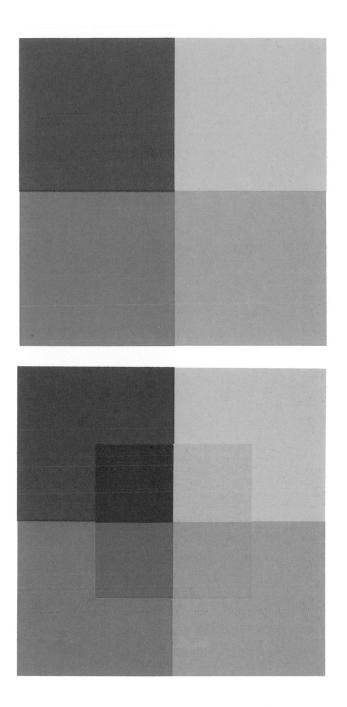

Hold plate x1v-2 so that the 3 figures appear side by side. A tetrachord of 4 juxtaposed reds (2 shades + 2 tints) is presented in 3 equal repetitions. The 4 reds are then transformed into 3 other hues—to 2 deeper keys of blue (left) and grey (center), and to a higher key of orange (right).

For a comparison of the intervals of the 4 tones within all 4 hues, the transformations are placed, in reduced size, in the centers of the 3 repeated red juxtapositions, now serving as grounds and thus as a common measure.

Although the blues may appear lighter than the surrounding reds, they factually are all darker than the neighboring reds in diffused daylight (indoors and outdoors), in full sunlight, and also in warm and in cool artificial light.

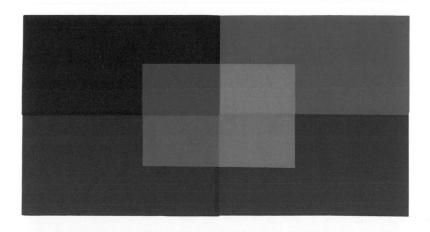

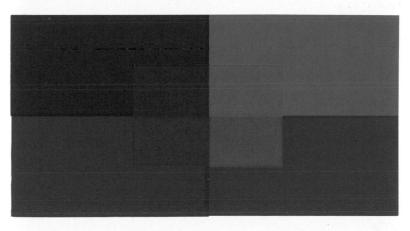

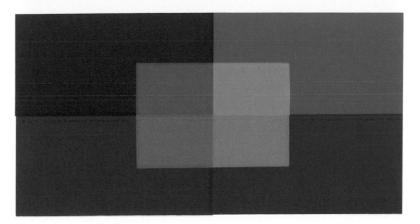

Here, 4 colors different in hue and in light are changed into 4 other colors equally different but of a higher key. Both tetrachords then exchanged present a convincing as well as pleasing transformation. Both are united by the lightweight left halves and by the fuller right halves.

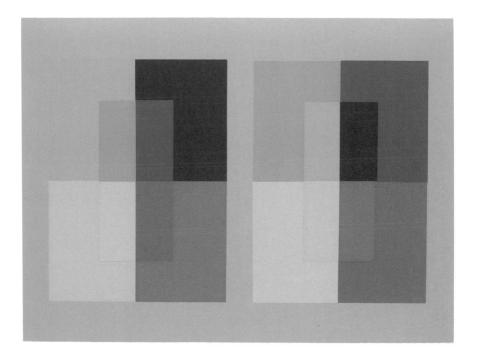

Intersection CHAPTER XV

XV-2

To achieve a new sculptural illusion of intersecting colors, note that the separating boundaries of a middle mixture look elevated, or raised from the ground, which causes a "fluting" effect known from the channelings of a Doric column.

Here is a "blown up" view of the fluting effect: Consider the dark red rectangle as a ground plan, and read the channelings as 2 side elevations.

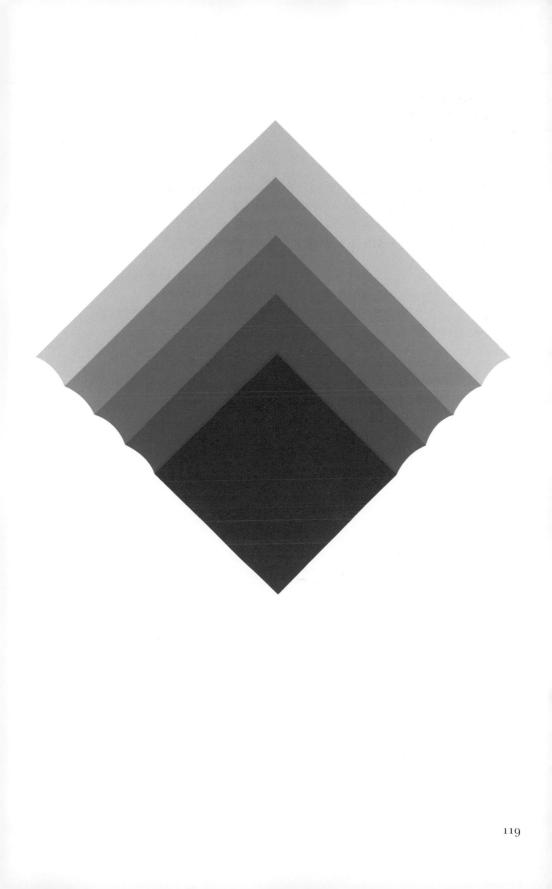

Quantity CHAPTER XVI

XVI-2

This is a stimulus for further variants. Look at them not as 1 group, but in series, rows, or smaller groups by blocking them out (with slip sheet or hands), and look at particular single studies through adjusted openings.

Select your favorite studies, and find the reason for your preference (but also for your rejections). And learn that your preferences won't be constant, but will change with time and your own conditions, just as prejudices do.

See that such systematic studies go beyond self-expression and avoid self-disclosure. Instead, they lead us to comparison, and so to evaluation, and further to self-criticism and self-education.

Please do not ask which is the "best" design, although we have seen this question printed, because, without further qualification as to cause and purpose, this question is both unjustified and irrelevant. It merely discloses the incompetence of the inquirer. (See comments on variants and variety, page 73 of the Text.)

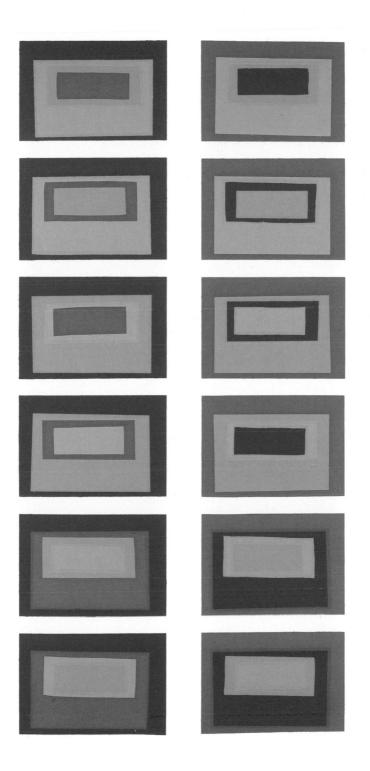

XVI-3

An unusual solution. Besides its representation in 4 circles and its subordination under a severe restriction—that is, a precisely repeated subdivision of the 4 circles—it demonstrates clearly the extreme cases of connection and separation within and among circles: The inner centrifugal enclosure —cohesion—against the outer centrifugal enclosure —adhesion.

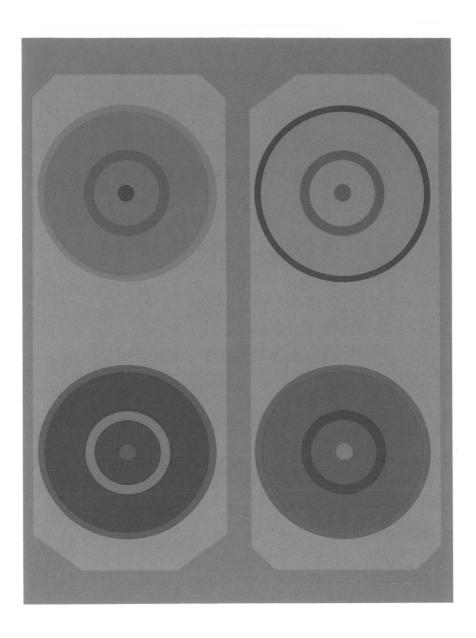

XVI-3 A most successful "quantity study," and an amazing reversal of the initial inclination to employ the ground as the largest area. Here, the figure above the ground dominates through recurrence plus amount, or repetition plus extension.

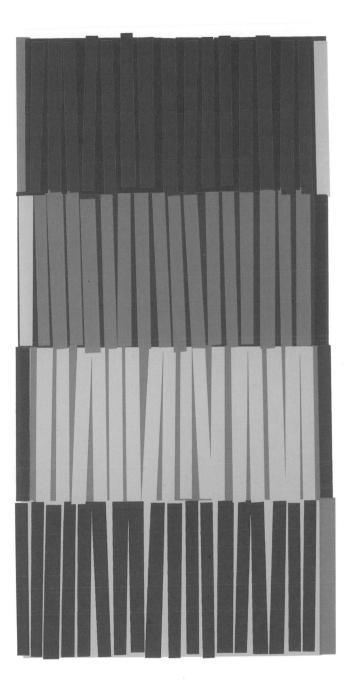

Film and volume color CHAPTER XVII

XVII-1

An illusion of film color indicating a sheet of almost clear acetate covering 4 colors, and at right covering even twice. But remember that the original study is done not in transparent material but in opaque paper, which, of course, demands a very precise color selection.

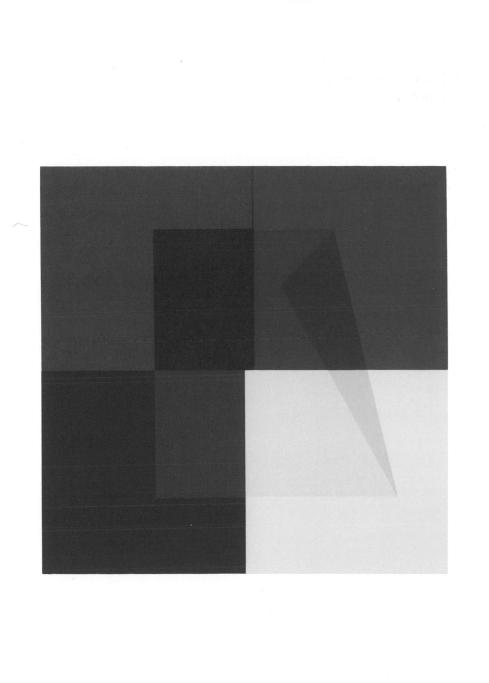

Free studies CHAPTER XVIII

XVIII-3

A double interaction between 2 dimmed tones of red and green combines 2 contrasting effects, an after-image with its opposite, an optical mixture.

Whereas the more frequent and even subdivision of the outer areas tends toward a greyed-down optical mixture, the after-image occurs in the elliptical center, where the green ground—after a figure-ground exchange—shows a larger broadening than the reds. The numerical reduction of stripes in the center consequently

produces a clear increase in both light and color for the green, but a gain only in color, with a loss in light, for the red.

All of this results in a subtle change in posture,

from an outer soft flatness to a central emphasis of direction. And both are reversed by a strong figure-ground change through the horizontal center line.

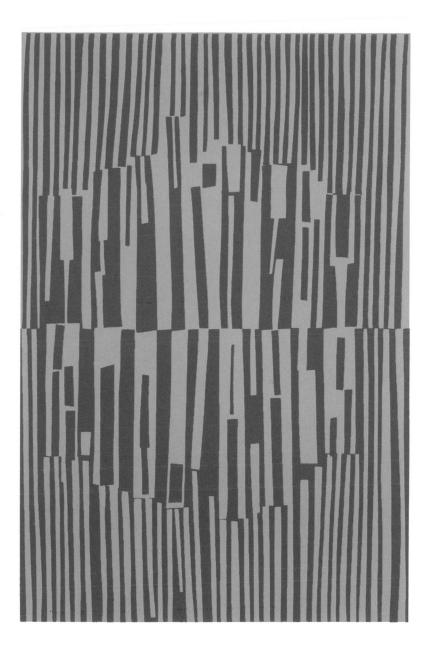

XVIII-9

An arrangement of stripes of very contrasting character. These can be read (from left to right) first, as warm and soft against hard and cool; second, with relation to interiors, as a heavy carpet against a light papered wall; and third, if considered as sounds, as woodwinds against brass.

In addition, there is a harmonious and sonorous assemblage of adjacent colors which makes the blues look warm. All these differences can be read despite the fact that all the colors appear in the shape of stripes, stripes which are all equally "hard-edged."

The Weber-Fechner Law CHAPTER XX

XX-1

2 gradation scales for a comparison of arithmetical and geometric progression in mixture of color (here red and black).Both are to be read downward, thus beginning with red.

(l.) To the upper red is mixed successively 1 - 2 - 3 - 4 equal amounts of black, as has been recommended by M. E. Chevreul (see Text, page 54) and which presents an arithmetical progression, but only physically, not perceptually.

(r.) To the same red is added successively 1 - 2 - 4 - 8 equal measures of black, thus presenting a geometric progression following the Weber-Fechner Law.

(l. & r.) Both gradations are alike within the first 2 steps.
And both have the same psychological or perceptual aim—
an arithmetical progression. But the results are different:
At left a diminishing increase of black;
at right a steady increase of black.
The difference shows still more clearly at a distance.

As we learned with illusional transparence, the pronunciation of boundaries measures spatial relationship. Consequently, all the steps at the right, including the last one, are separated by equally clear edges, which give them equal height. At the left the steps merge visually more and more as we look downward, and the last separation is least recognizable. Both results prove the Weber-Fechner Law—indirectly at left, and directly at right.

After producing such scales in pasted layers of very lightly colored acetate sheets, accompany them with linear diagrams, showing in steps, or in continuous lines, (a) the physical content and (b) the psychological effect of both scales.

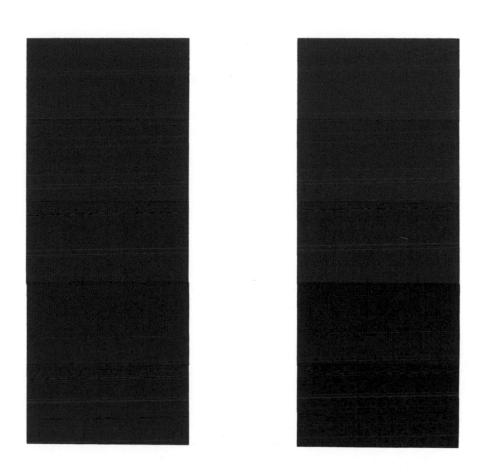

Warm-cool Chapter XXI

XXI-1

Red and blue, usually representing warm and cool, are placed alternately on the left and right sides to demonstrate that both colors can look high as well as low in temperature. Such a placement will easily provoke disagreement. But a reading of all the left halves warmer than the paired right halves is not unreasonable.

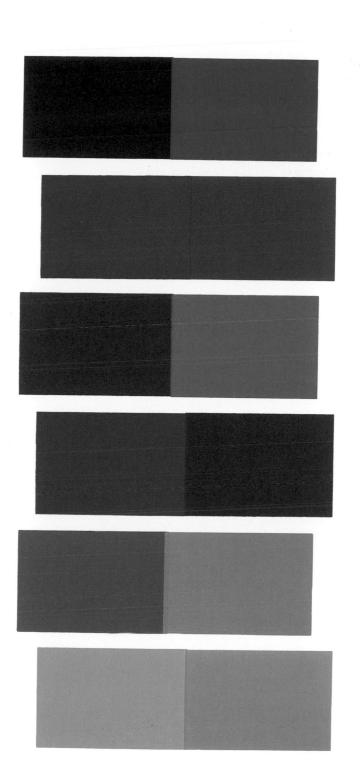

Vibrating boundaries CHAPTER XXII

XXII-1

2 contrasting or near-contrasting colors are arranged
to produce an effect of vibrating boundaries (see Text, page 61).
In case you wear glasses, look at the studies with and without them, and, if possible, in near and far focus.
Distinguish also where the doubling of the contour occurs, outside or inside of the figures.
Observe them also in daylight and in different artificial lights.

Notice that these studies are done in regular color paper, not in so-called "day-glow" paper. Whereas the effect of the latter depends on a new kind of fluorescent pigment, here the vibration effect appears as an illusion for which we have no known explanation.

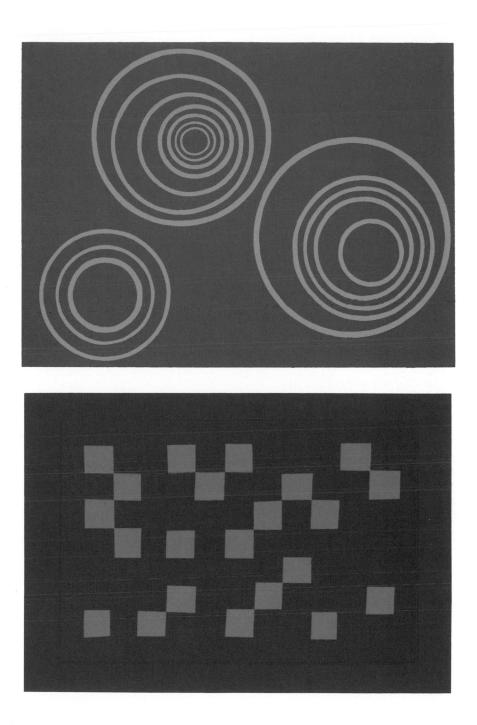

XXII-2

2 studies of precisely the same arrangement, but with reversed colors. That the vibrating boundaries look different on both sides is probably the result of the changing color quantities of figure and ground.

For another reading of such illusionary vibration, one can recall auras and halos.

Equal light intensity CHAPTER XXIII

XXIII-2

Here is a figure extending sideward and with many sharp corners. Although all shapes are similar triangles, clearly constructed—with pointed corners and straight lines—we cannot be sure in the top figure whether we see, at a short distance, several figures or only 1. And it is not possible to count all the triangles, much less their corners. The contours vanish because the 2 colors are of the same light intensity. Only when the triangles are seen against a white background is it revealed that there are in fact 11 triangles with 21 corners.

Color theories CHAPTER XXIV

xx₁v-1 The Equilateral Triangle

It is probably the most condensed and clear system of presentation of an essential order in the vast world of color. Within the 2 dimensions of an equilateral triangle—subdivided in 9 similar triangles—are 3 primaries, 3 secondaries, and (unexpectedly) 3 tertiaries, all placed very sensibly.

The first of the 3 trios, containing the strongest color contrasts, appears most separated, at the extreme ends—in the 3 corners. Yellow and blue (which Goethe called "the only 2 pure colors," and also "the primeval contrast") appropriately hold the base. And red ("the middle between them") occurs high off at the apex, again separated but in a middle place. The less opposite secondaries are in the middle of the outer edges, and the closest, or least different, tertiaries naturally meet still more in the center.

The drawings on page 66 of the Text show 3 more groupings which invite further study of relationships within the groups and also among the groups.

We suggest copying the 9 groupings on tracing paper (on top of the equilateral triangle) and cutting them as stencils for further comparisons.

Leaf studies

xxv-2 & xxv-6

The studies of pressed fall leaves and color paper do not need detailed description.
Notice how different they are, and see them as independent work of students trained in basic class exercises which aim first at single color effects only, and thus train for the development of active color relationship—by practical realization of color interaction.

Recognize the manifold use of the material, the changing organization and presentation—unhampered by either harmony or disharmony, but led by respect for both—discord and concord.

XXV-2

xxv-6

Josef Albers, one of the most influential artist-educators of the twentieth century, was a member of the Bauhaus in Germany during the 1920s. In 1933 he came to the United States, where he taught at Black Mountain College for sixteen years. In 1950 he joined the faculty at Yale University as chairman of the Department of Design; after his retirement in 1958 he was named emeritus professor of art, a position he held until his death in 1976. The recipient of numerous awards and honorary degrees, Albers was elected to the National Institute of Arts and Letters in 1968 and in 1971 was the first living artist ever to be given a solo retrospective at The Metropolitan Museum of Art in New York.

Nicholas Fox Weber is executive director of the Josef and Anni Albers Foundation.